WIJSENBEEK · PIET MONDRIAN

PIET MONDRIAN

by L.J.F. Wijsenbeek

Translated from the Dutch by Irene R. Gibbons

NEW YORK GRAPHIC SOCIETY LTD.

Greenwich, Connecticut

Published in New York by New York Graphic Society Ltd.
Greenwich, Connecticut 06830, U.S.A
Standard Book Number 8212—0339—8
Library of Congress Catalog Card Number 69—19514

© 1968 Verlag Aurel Bongers Recklinghausen
First published in Germany 1968 by Verlag Aurel Bongers Recklinghausen

Printed in Germany

Contents

Spiritual background
and naturalistic beginnings

A Pieter Cornelis Mondriaan, the father of the artist, about 1870 (photo)

B Johanna Christina Mondriaan, née Kok, the mother of the artist, about 1870 (photo)

C "Thy word is the truth" painting by Mondriaan Sr.

D The painter Frits Mondriaan (1853—1932), Piet Mondrian's uncle (photo)

E Piet Mondrian with his sister and brothers, 1890 (photo)

```
A│C
B│D
 │E
```

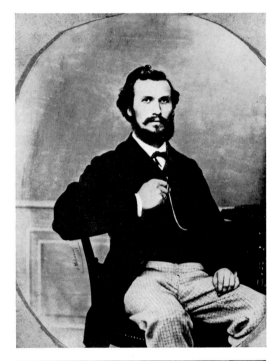

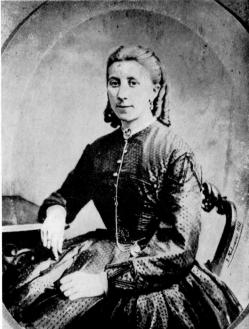

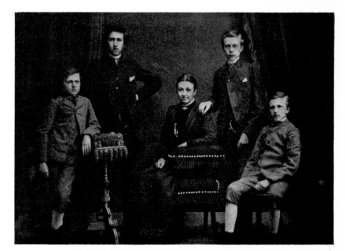

At the Monastery of Mount St. Agnes in Zwolle Thomas à Kempis wrote in his chronicle: "The Netherlands seemed to be passing through a Golden Age." But he was in fact referring to the long period when Frederik van Blankenheim, Bishop of Utrecht, was ruling over his domain with a rod of iron. Thomas is certainly the most widely read theologian to come out of the Low Countries, and yet his chronicle hardly mentions the political turmoil that was going on all around him.

As Conrad Busken Huet[1], the first Dutch social historian of the nineteenth century, put it, "there is nothing to show that Thomas à Kempis was a contemporary of Philip of Burgundy." Thomas admitted that he liked books and quiet corners all his days. He withdrew "cum libello in angello" from that troubled world and took little interest in the political and social events of those vital years. And yet that was the very period when the Netherlands as such were beginning to take shape and the seven free provinces were about to emerge. In spite of this, his "Imitatio Christi" made a very definite impact on European thinking. That book, more than any other, modernized the contemporary attitude to God and religion and also had an influence on succeeding generations. He himself had been brought up in the little Dutch town of Deventer, in the spiritual tradition of the Brothers of Common Life (*Broeders des Gemeenen Levens).*

I am quite deliberately starting off with a reference to Thomas à Kempis, although this book is about Pieter Cornelis Mondrian, the greatest Dutch painter of the twentieth century. There is actually a remarkable similarity between these two men who grew up in the Netherlands. They shared a certain type of spiritual environment, and Mondrian's work also does not reflect the turbulent period in which he lived.

• Pieter Cornelis Mondrian (the original spelling was Mondriaan, but he himself changed it after settling in Paris) was born on March 7th, 1872.• He was a son of the headmaster at the Christian Reformed School in Amersfoort and was called Pieter Cornelis after his father. Theirs was a strict Calvinist household, whose whole spiritual attitude was very like that of the Brothers of Common Life. The humility preached and practiced by the Brothers also entered into the form of Calvinism favored by Mondrian's father. I am not the first person to see a similarity between these two religious doctrines, but it has only gradually dawned on us that the similarity has been brought about entirely by the Dutch character. There is an old French saying: "God created the world, but not Holland — the Dutch made that themselves." This idea is not couched in very respectful terms, but it is true nevertheless. Holland has been gradually built up in the course of a never-ending struggle against the sea, and the Dutch character has been molded by that struggle It has produced sober, hard-working men of simple tastes, who have had to battle tirelessly and with grim determination against the forces of nature. They have had to defend their country and their very existence. Holland is spread out between the vast expanse of the heavens and the mighty sea, and people who are born there and have had to work

there are never allowed to forget man's limitations and the constant presence of a Higher Power without Whom all life and work would be impossible. This idea led to the formation of the Brothers of Common Life in the fourteenth century and later on, in the sixteenth and seventeenth centuries, transformed the French brand of Calvinism into a religion that was truly Dutch in character.

It has often been said that the straight lines formed by canals and dikes, so typical of the Dutch scene, are reproduced in the later work of Mondrian. This is certainly not true in a strictly literal sense. But it does apply up to a point, as the rectilinear pattern of the Dutch landscape is somehow reflected in the spirit of the Dutch people. The creative work of Piet Mondrian stemmed from his character as a Dutchman — a character that has expressed itself in a number of different spiritual movements down the centuries[2]. I shall be returning to this subject later on, but before really launching into the life history of Mondrian the painter I wanted to identify what I feel to be the characteristic underlying the whole of his work, and that is his belief in the relation between mind and matter — a belief that is deeply rooted in the character of the Dutch people.

The house in Amersfoort where Mondrian was born stood on the Korte Gracht. His father had taken up residence there a few years previously, when he was appointed headmaster of the school situated next to it.

Piet's father's family came from The Hague and so did his mother's. She was born Johanna Christina Kok. Both parents had been born in The Hague, and they were married there. The Mondriaan family belonged to a line of tradesmen in that city that can be traced back to the seventeenth century. The artist's grandfather was originally a wig-maker and later a barber. But where did Piet Mondrian's artistic gifts come from? His father is said to have had a flair for drawing, but little of his work has been preserved. However, from what Mondrian's younger brother Karel has told Michel Seuphor, the first to write a biography of the artist[3], the father's talent was highly thought of by those who knew him because of the excellent blackboard drawings he did for his classes. They showed scenes from the Bible and there was, of course, the traditional picture of St. Nicholas which was put up to commemorate the Saint's festival on December 6th, a day specially celebrated even in Protestant Holland. But Piet's father was not the only member of the family who displayed artistic talent. His uncle, Frits Mondriaan, was a professional painter and one of the lesser masters of the Hague School. Paintings by him can still be seen in collections in The Hague. We also come across his works occasionally at auctions, but this is becoming a rare occurrence: his paintings are practically identical to those produced by Piet Mondrian in his first creative period and the F in the uncle's signature (he signed himself F. C. Mondriaan) has often been changed into a P merely by adding one small stroke. When looking at the youthful works of Piet Mondrian, therefore, we will do well to examine them closely to make sure they were not in fact done by his uncle. Frits Mondriaan was a landscape artist,

10

and his paintings display the indeterminate coloring usually found in the Hague School at that time. He it was who gave Piet his first painting lessons. Later on, the uncle dissociated himself completely from his nephew, whose style of painting had become too modern for his taste.

Piet wanted to be a painter even when he was a boy, but his father was unwilling to grant his wish. This is quite understandable in view of his general character and ideas. But he finally gave in, on condition that Piet gain a diploma first. In 1889 Piet was awarded a diploma entitling him to teach drawing in elementary schools, and in 1892 he gained a further diploma qualifying him to give lessons in secondary schools as well. Never in the whole course of his life did he actually make use of these diplomas — this fact is mentioned by Seuphor — but he preserved them carefully as evidence to show people that he was a perfectly competent draughtsman and had attained the proper academic standard. Thus he was ready to refute any vicious allegations regarding his professional qualifications as a painter.

Having carried out his father's wishes, Piet Mondrian began to devote himself entirely to painting. From 1892 to 1895 he attended the painting class of August Allebé at the Rijksacademie in Amsterdam. This man was not only a leading professor, but also a well-known contemporary painter. During the next two years Piet only attended evening classes at the Academy. In the daytime he went out looking for ideas and inspiration in the countryside around Amsterdam. He found a number of attractive subjects for his pictures, especially in the vicinity of Duivendrecht and the little river Gein — landscapes with small farms set near the water's edge and surrounded by clumps of trees. Although the painting and composition were good, these pictures give us the impression of being pure visual reproductions of the scene. But soon, especially in the drawings, Mondrian seemed to be aiming at something more than just an objective re-creation of the landscape stretching out before him. He wanted to go beyond the painters working in The Hague and Amsterdam at that time. The leading figures in The Hague were the Maris brothers and Anton Mauve, the uncle of Vincent van Gogh, and in Amsterdam there was Hendrik Breitner, who was the first to bring fame to that city's school of painting. While these painters tried to portray the atmosphere of the scene, even in those days Piet Mondrian's landscapes presented a combination of large surfaces. He had a different way of looking at things. Mondrian clearly saw the scene before him with its clumps of trees and houses and so on as a combination of sharply defined masses contrasting with one another, whereas in the works of the other painters these masses all became merged in the pervasive atmosphere of the scene they were depicting.

Water plays an important part in the early pictures of Mondrian. In the foreground we almost invariably find a stretch of water with the small farms or boats, which are the real subject of his

11

pictures, standing out against it. We can quite truthfully say that these pictures, viewed individually or as a group, do not contain anything completely new. They are good pictures, but certainly nothing out of the ordinary; they represent the work of a young artist searching for his own true path. If Mondrian had not, by dint of hard work, achieved his ultimate goal and ambition — the creation of an absolutely pure form of painting — we would certainly not regard these pictures from his early days as being at all unusual. They only become interesting in the light of his later work, because they mark the starting-point in his future line of development. They reveal a young artist with a sensitive awareness of the Dutch scene and a personal way of looking at things.

We get the same impression if we study the works of the young Rembrandt or the young van Gogh. In their early pictures they both show themselves to be gifted, but not exceptional, painters. Then we see the mental and spiritual powers of these great masters gradually developing, together with their ability to express these gifts more and more completely.

Looking at Mondrian's pictures is a curiously fascinating experience. We can detect a plan slowly forming in his mind — a plan that would one day revolutionize painting in Holland and all over Europe. We seldom have an opportunity of following the steady evolution of an artist step by step as we do in the pictures of Mondrian. The gradual development of his artistic powers of perception can be seen particularly clearly in the many drawings and paintings of a certain farm near Duivendrecht that have been preserved. It had become one of the young painter's favorite subjects.

This continual process of evolution does not, however, imply a steady advance, leading up to a picture shorn of all accessories and with only the spiritually and artistically essential features remaining. There are bound to be relapses and backward glances. We definitely know from statements made by friends of his who are still alive and also from the detailed investigations of Robert Welsh and C. Blok that pictures and drawings of that particular farm, composed and built up in a rigidly austere manner, were followed by pictures completely evoking the atmospheric style of the Hague School. It is hard for any young painter to break away from the style that happens to be most popular during his formative years. This is particularly true if, like Mondrian, he has to rely on selling his pictures in order to earn a living.

But analysis of these early series of drawings and paintings clearly reveals that Mondrian was searching for new forms that would enable him to express the clarity he was striving to attain.

Again and again he explained the aim he had in view. In so doing, he became aware that, unlike his older fellow-countrymen, he did not regard atmosphere or the effect of light on the world around him as the essential feature of his art. He wanted to combine what he saw and build it up into a definite system or pattern and so express his artistic aspirations autonomously, as it were, in pictorial form. We ourselves are so far away from that particular period that it is not easy for us to pick out the

fundamental difference between the works of painters belonging to the Hague School and pictures in which Mondrian was trying to follow an independent path of his own, mainly because at first he remained closely attached to the Hague School in his choice of colors.

If we look at the pictures painted by Mondrian in the early years of this century, especially beside the river Gein, we find one particular subject recurring again and again — i. e. trees, which were to be a source of inspiration to him throughout his artistic career. We may feel tempted to draw certain psychological conclusions from this fact. Indeed we find that the two great masters of modern Dutch art, Vincent van Gogh and Piet Mondrian, used trees again and again throughout their lives to express their deepest emotions. On this basis we might feel like establishing some sort of connection between van Gogh and Mondrian. But, if we put a typical van Gogh tree and one by Mondrian side by side and examine them closely, we will be quite amazed by what we see. The two trees evoke completely different moods. We come across this contrast again and again in the works of these two painters — a contrast apparently based on differences in their characters. In the case of van Gogh the tree reveals a lonely, tormented soul in a perpetual state of agitation. His tree trunk twists and twines and divides into branches that reach up to the sky like arms raised in blind despair. Mondrian's approach is quite different. His tree with its leafy top expresses life and movement, but it is complete in itself, giving a sense of repose. Mondrian's constant preoccupation with unity and with completeness and continuity of form made him concentrate more and more on basic shapes.

At the start of his career Mondrian arranged his trees in groups, just as he saw them in nature — huddled protectively around a farm or planted in a line along a canal — but, as the years went by, the solitary tree gradually became the dominant form in his work. I feel sure that this has a psychological explanation. We get the impression that in his early years he tried to derive strength and support from his association with young painters and friends who shared his ideas (painters like Simon Maris and Hulshoff Pol and the forester van den Briel, who was another kindred spirit). But, as he went on developing, he became aware of his own special ideas and potentialities. It gradually dawned on him that he had to go his own way, quite alone, and follow that road right to the end. Are we trying to read too much into all this? I do not think so. A painter, after all, is said to reveal himself most clearly and completely in his painting. And, although van Gogh and Mondrian kept a written record of many of their ideas, painting was their main means of expression. They used their paintings to portray their own true natures in their own special way. But they were always restricted by the materials that a painter has at his disposal — a canvas and colors. In his work van Gogh struggled to free himself from the limits imposed on him by his materials. Again and again we get the impression that he actually felt like destroying the canvas. He looked on canvas and paint as means to an end: he needed them to exteriorize his emotions. Mondrian on the other hand, became aware, as time went

on, that a painter can only express himself on canvas (or something similar) and so he must take the canvas as his starting-point. He came in this way to recognize the autonomous value of the canvas and the existence of the two-dimensional surface as such. In conveying his message, he therefore adapted himself to the two-dimensional nature of the canvas. The final result of this is to be found in Mondrian's Neo-Plastic pictures, in which all suggestion of Illusionism has been suppressed and indeed removed. In all painting there is no better example of the contrast between the Dionysian and the Apollonian character than in the pictures of van Gogh and Mondrian. It is really quite extra-ordinary that this contrast should come out so strongly in modern times in the works of two Dutch-men — two painters of the same nationality, each of whom can be pointed to as a typical representative of the land of his birth. This contrast is also clearly evident in the whole process of evolution in the two men. Van Gogh produced a tremendously large number of artistic works in the short space of six years, thus showing an explosive pattern of development. Mondrian, on the other hand, seems to have evolved in an even, balanced fashion without any major convulsions.

The difference between their characters is also reflected in their working methods. Vincent poured out his tempestuous feelings and slapped them straight on to the canvas with his brush, but Mondrian began each of his pictures by making a great number of detailed studies first. Only when he was completely clear about the problems that he wanted to present did he set about producing the final version.

The contrast evident in the paintings of these two artists is also apparent in their writings. Both of them have left us with an important and fairly comprehensive body of literature. Vincent's writings are confined entirely to personal matters. They always take the form of a personal discussion with his brother or his friends and are an immediate record of what he felt at the time of writing, so we might well refer to them as a diary in the form of letters. Mondrian was quite different. He expressed himself in essay form. In these essays he philosophized and put down his ideas concisely and with precision. Like his paintings, his essays were the result of a lengthy process of preparation and were scrupulously trimmed and shaped, down to the minutest detail. It might be said that van Gogh used the "open" form and Mondrian the "closed" form. Mondrian expected anyone who wanted to enter fully into his painting to join with him in working out all the various questions in his mind and in accepting certain basic philosophical principles. Van Gogh, on the other hand, spoke out plainly — man to man — and tried to win the other person over by an appeal to the heart.

1 Conrad Busken Huet, Het Land van Rembrandt, Haarlem, 5th ed., part 1, p. 187.
2 For example, the Rijnsburg Fraternity in the seventeenth century.
3 See Michel Seuphor, Piet Mondrian, New York, p. 44.

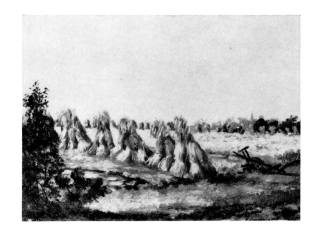

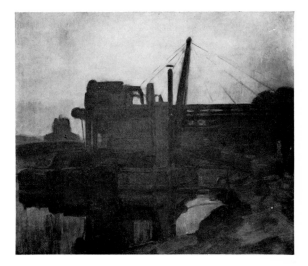

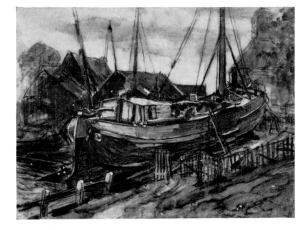

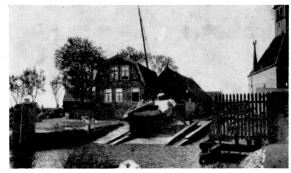

```
1 | 4
2 |
3 |
```

1 Corn stocks 1891
2 Drydock at Durgerdam 1898 watercolour
3 Photograph of a drydock at Durgerdam
4 Dredge 1907

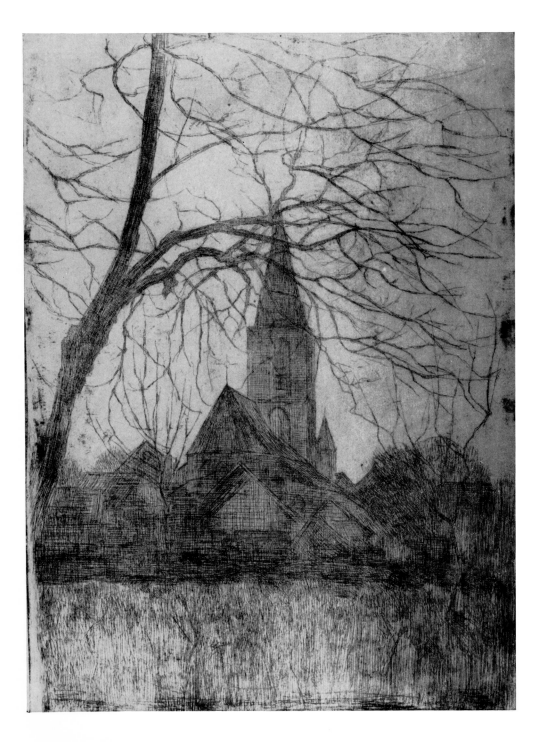

5 Church at Winterswijk
1898 etching

16

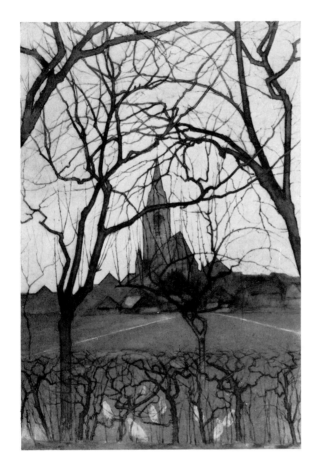

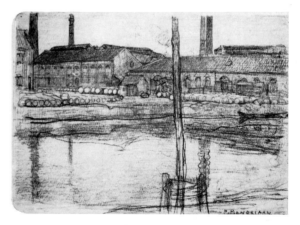

```
6 | 7
——————
  | 8
——————
  | 9
```

6 Church at Winterswijk 1898 oil on paper
7 Farm near Blaricum 1898/1900
8 Factory 1899
9 Contemporary photo of the same factory

17

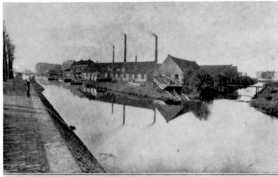

· · · · KONINKLIJKE FABRIEK VAN WASKAARSEN · · · ·

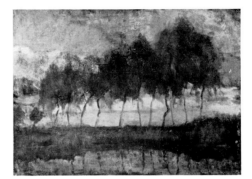

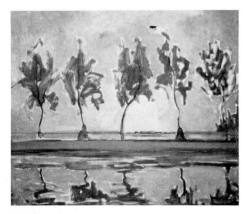

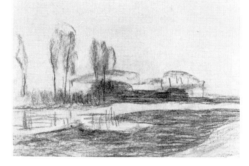

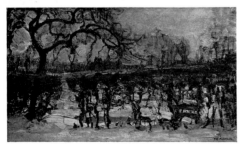

10	13
11	14
12	

10 Sketch of cows 1904
11 In Het Gein: trees with rising moon 1907/08
12 Winter landscape 1907/08
13 Trees in Het Gein 1905/06
14 The Amstel, "evening mood" 1906/07

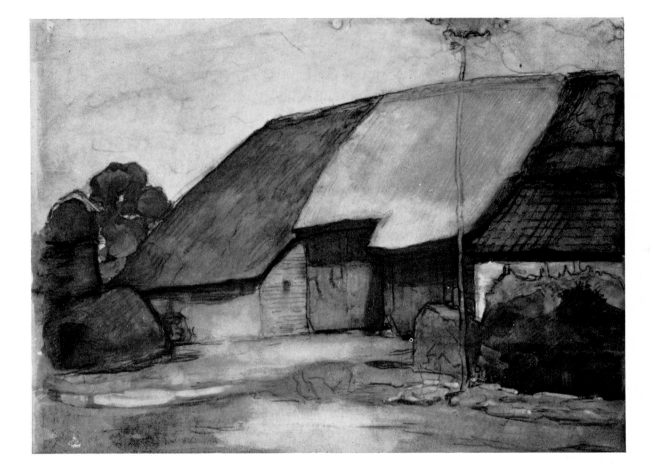

15 Farm at Nistelrode 1904

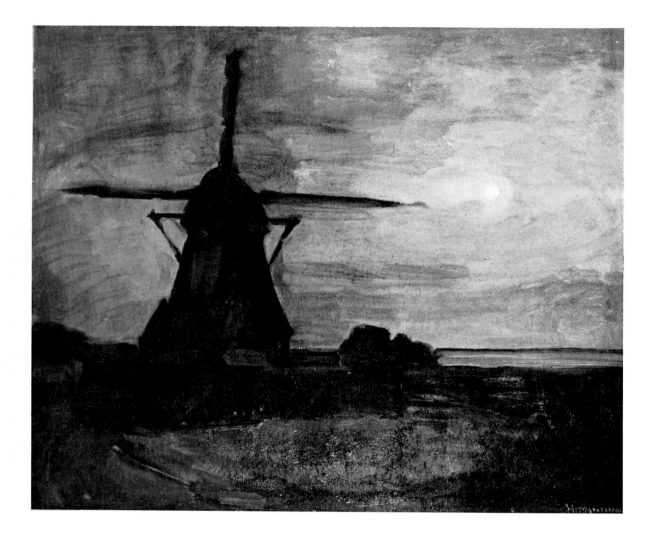

16 Windmill near Blaricum in the moonlight 1906/07

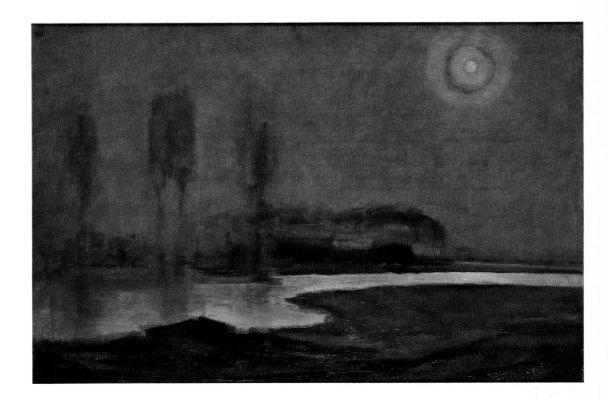

21 17 Summer night. Landscape with a full moon 1907

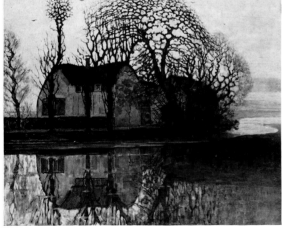

18 | 20

19

18 Farm near Duivendrecht 1905
19 Farm near Duivendrecht about 1906/07
20 Trees in Het Gein 1905/06

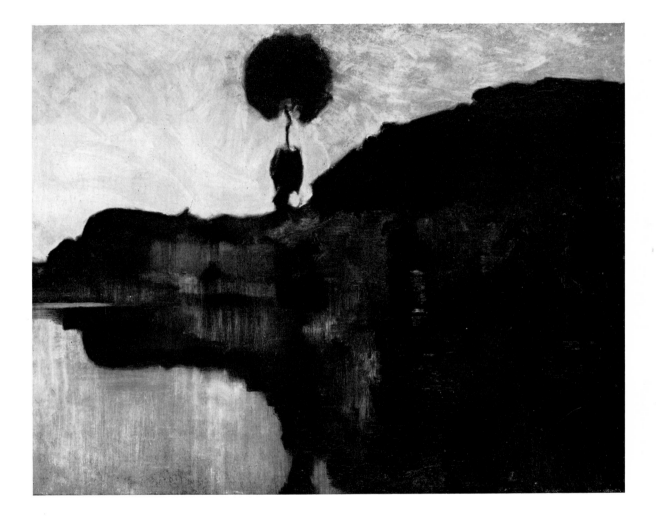

23 21 The solitary tree 1903/06

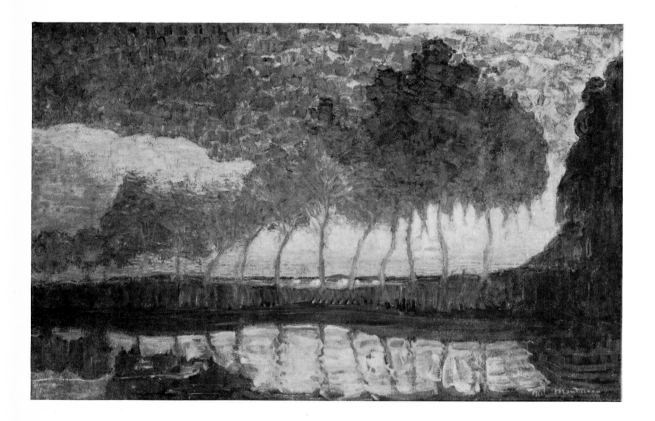

22 Trees in Het Gein 1908

24

Painter of light

```
 F |
---|  H
 G |
---|---
   | I|J
```

page 28:

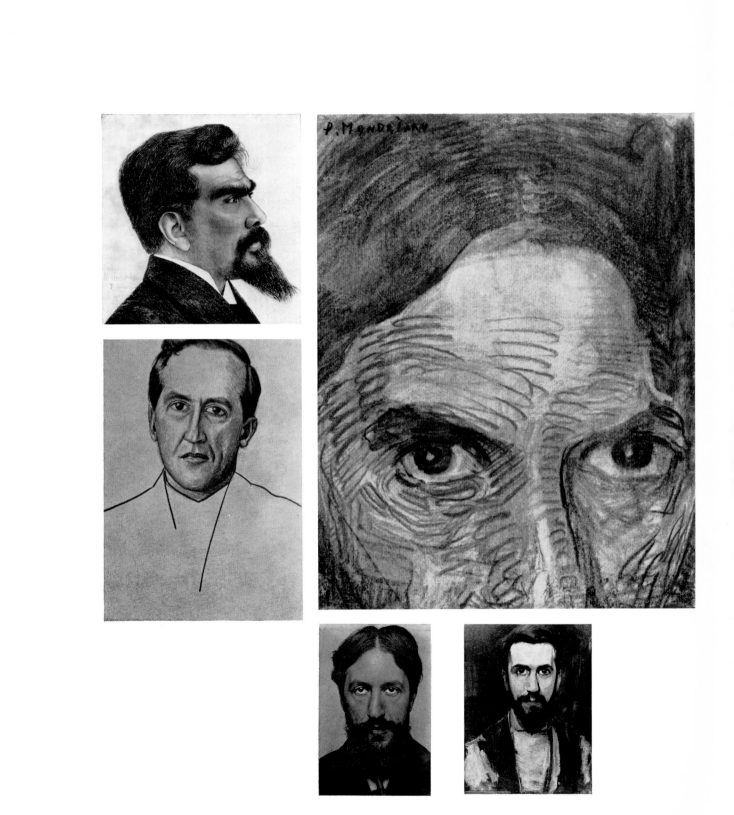

27

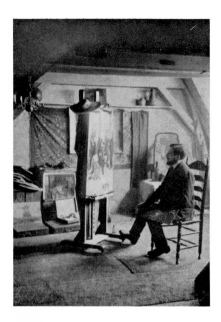

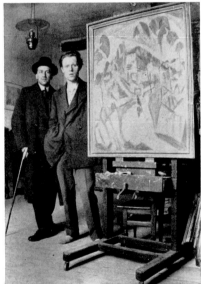

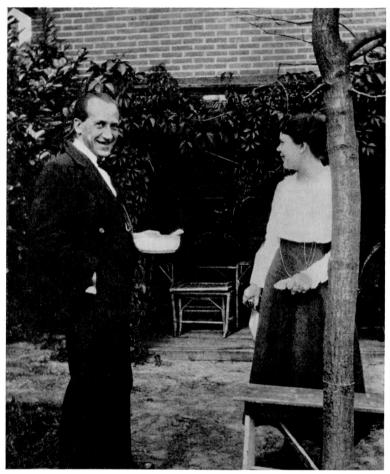

K | M
—
L

In the years from 1897 to 1908 Mondrian was steadily trying to master the art of painting. In 1908, when he was no longer a very young man — he was thirty-six — he went to Domburg in the province of Zeeland for the first time. Here a radical change took place in his whole style of painting. He had been paving the way for this during the past ten years and now the time was ripe. His attention had been focused on form and color, the two main ingredients of painting, and he had made a very careful study of them. Form had become rather vague and hazy in the atmospheric style of painting practiced by the Hague School, but Mondrian brought it back into his systematically constructed pictures and made it once more a complete and continuous whole. He also had to master an entirely new way of using color. His early paintings have a rather indeterminate quality, and the little color used is always of some intermediate shade.

In the period from 1904 to 1905 he lived at Uden in Brabant near van den Briel, the forester, whom we have already mentioned. His close friendship with that calm, thoughtful man helped him to gain a clearer picture of the path he ought to follow. In the works from this period we do indeed see the clear, individual style of Mondrian slowly asserting itself. In 1905 he returned to Amsterdam and lived there, with only temporary absences, until 1911. First he occupied a studio on the Rembrandtplein in the attic above the Guild of St. Luke, a society for painters; later he went to live at 272 Albert Cuyp Street. He was a member of the Guild of St. Luke and exhibited work under the auspices of that society until 1910. Using the subjects and ideas he had brought back from Uden, he worked resolutely on, trying to develop a style of his own. But he continued to paint in the old way as well, in order to earn his living. As a source of income, he made scientific drawings of flowers and plants for the biologist Professor van Calcar in the period 1905–1906. These drawings and watercolors of flowers that he was commissioned to produce also inspired him to create a completely independent series of really delightful flower pictures. Indeed, the chrysanthemum seemed to hold a special fascination for him. He sent one of these watercolors to Queen Wilhelmina in 1909 as a gift marking the birth of the present Queen, Juliana.

No one can fail to appreciate the poetic charm of these works, which reveal an aspect of Mondrian's personality that hardly ever appears in his other pictures. On the one hand we find emotionally restrained paintings based on straight lines and on the other paintings like these, tinged with a wistful note of poetry and melancholy.

During his stay in Amsterdam, Mondrian came into contact with the Theosophical Society, and its doctrines made a very strong impression on him. Some of his pictures are highly symbolic in tone and bear witness to this new interest of his. Symbolism was, of course, becoming popular in Holland around that time, thanks largely to the efforts of great Symbolists like Jan Toorop and Thorn Prikker. I myself

am not very enthusiastic about Mondrian's attempts at Symbolism. In my opinion his Symbolist painting is too artificial and academic, and he was unable to handle theosophical subjects in a suitably harmonious manner. These pictures cannot be considered successful from an artistic point of view either, as the form he used was borrowed and not original. But theosophy did certainly influence his ideas considerably and helped him to evolve his own private concept of the universe.

In addition to these theosophical overtones, we can also detect the influence of painters from other countries in various works dating from that period. He was able to see their pictures at the exhibitions that were then being held regularly in Amsterdam, mainly under the auspices of the *Moderne Kunstkring* (Circle of Modern Art), of which he was a committee member. Amsterdam was a great centre of artistic life in the Europe of those days. Works by the French Fauves or the German Expressionists were shown there very soon after these painters had succeeded in catching the public eye. The potency of color as a means of expression — an idea common to both movements — also occupied Mondrian's attention for a time. Good examples of this are "Evening Landscape" and "Woods near Oele." In the "Evening Landscape," which displays Fauvist influence, a farmhouse and a few trees are enveloped in an intense, rich blue. When we were inspecting together the Mondrian Collection at the Gemeentemuseum in The Hague, Jean Cassou, a former Director of the Musée National d'Art Moderne in Paris, confessed to me that of all Mondrian's pictures that was probably the one that appealed to him most. This does not surprise me at all.

"Woods near Oele" is a hymn of praise to nature, a picture of dripping, rain-drenched trees immediately after a shower. The sun's rays, which are just beginning to break through again, are reflected in the pools of water, forming an enchanting colored pattern. This picture instantly reminds us of Edvard Munch, the great Norwegian, who was one of the figures in attendance when German Expressionism was born. Mondrian must have seen works by Munch at an exhibition in Amsterdam or at least come across reproductions of them in magazines. These had obviously made such a deep impression on him that a clear memory of them lingered on in his mind as he was building up the color composition of that great picture. He painted "Woods near Oele" in the summer of 1907, which he spent with his friend the painter Hulshoff Pol at Oele near Hengelo. During those years Mondrian was approaching a crossroads in his artistic career. He needed those contacts with the works of Munch and the French Fauves — those artistic confrontations — because they helped him to get a clear picture of the way he himself had to travel. He was then thirty-five years old and had prepared himself spiritually and mentally, and also technically, for what lay ahead in the years to come, when he climbed beyond the others to the very top.

I have already referred to Mondrian's great admiration for the work of Jan Toorop. He presumably met Toorop for the first time at the Guild of St. Luke. Toorop was also a member of the Guild and

showed pictures at its exhibitions. He was working at Domburg (1907–1908), which was then a flourishing center of artistic life. This activity was concentrated around Loverendale House, which belonged to the painter Marie Tak van Poortvliet. She was interested in all things intellectual and was an enthusiastic believer in anthroposophy. Her very special interest in painting was encouraged by her close friendship with the aristocratic Jacoba van Heemskerck, the only Dutch member of the Berlin group of Expressionist painters known as *Der Sturm.* It must have been Toorop who introduced Mondrian to the two women at Loverendale. Toorop had become acquainted with Pointillism and Symbolism in Brussels through the two associations referred to as *Les XX* and *La Libre Esthétique.* They both made an instant appeal to him, as they were in tune with his own character and origins — his mother was Javanese. In addition to his Pointillist paintings, he drew Symbolist pictures, whose beauty can best be described as "musical."

Pointillism began with the investigations carried out by Georges Seurat (1859–1891), who called his own particular type of painting Chromoluminarism. It later became known as Divisionism or Pointillism. Seurat's inspiration had been derived primarily from the scientific writings of Eugène Chevreul on the breaking up of light into its primary colors. Mondrian was busy even then with the problem of producing pure color, and he too was enthusiastic about this new and exciting method, which would make it possible to exploit the full potentialities of the color scale. The curious thing about all this is, however, that the Pointillists were aiming at a more authentic reproduction of the effect of sunlight in nature, whereas Mondrian was trying to do virtually the exact opposite. Later on, when he was in America, he explained it as follows: "I had come to feel that the colors of nature cannot be reproduced on canvas. Instinctively, I felt that painting had to find a new way to express the beauty of nature." *(Plastic Art and Pure Plastic Art,* New York 1945, p. 10.) Here Mondrian confirmed that it was the basic *theory* of Pointillism that had been the prime attraction for him.

After his first sojourn at Domburg in 1908 he received an invitation to return the following summer. So Mondrian went to stay near Loverendale in 1909 and 1910 and gave drawing lessons to Jacoba van Heemskerck. She modelled herself so closely on her teacher that it is hard to differentiate between the work she did during those years and his own. A large number of drawings by Jacoba van Heemskerck can be seen in the Boymans-van Beuningen Museum in Rotterdam, which also possesses drawings by Mondrian.

During those years Mondrian was giving a great deal of thought to the problem of the two-dimensional surface and, above all, to color. As time went on, he became increasingly aware that color had to be given a new and different role in his pictures. He had not yet started painting abstract works, but tendencies in that direction were becoming clearly evident. He was primarily concerned at that time with solving the various technical problems connected with painting and, being the type of man

he was, he did not begin to build up his own system of ideas until he had calmly and thoroughly investigated these problems and evolved a reliable working basis for his painting.

I have already referred to the fact that Mondrian joined the Theosophical Society in 1909. He made a long and detailed study of its teachings, and the ideas of Krishnamurti made a particularly strong impression on him. In fact, a book by Krishnamurti was one of the very few printed works that stayed with him until the end of his days. Although he was a keen and avid reader, he had no desire to own books. But this particular book meant a great deal to him and he often discussed it with friends, including Michel Seuphor, right up until the last years in America.

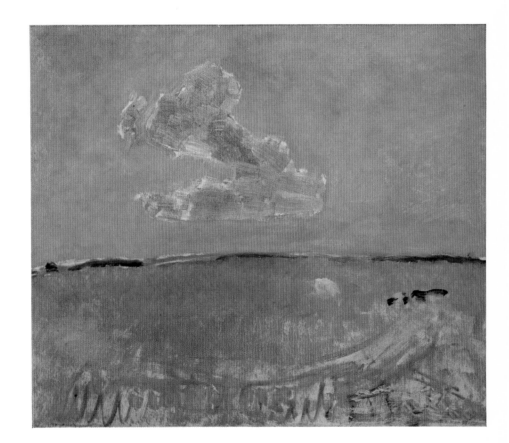

23 The red cloud 1907/09

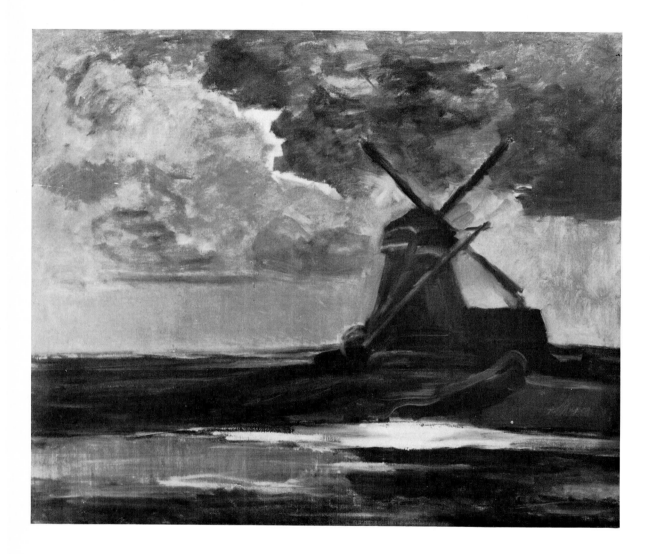

24 Windmill in Het Gein 1907/08

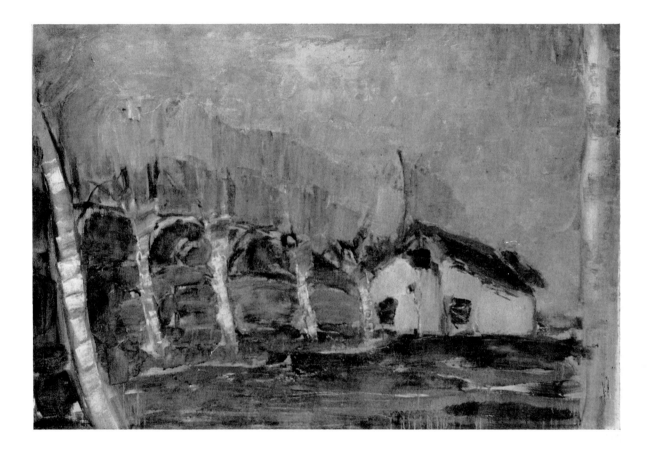

25 Evening landscape 1907/08

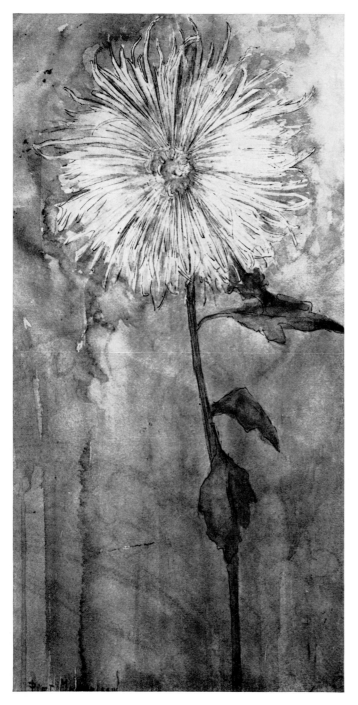

26 Chrysanthemum 1901

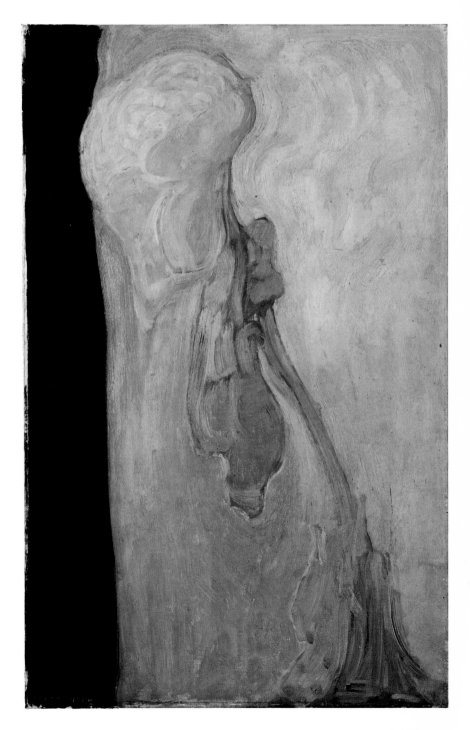

27 Dying chrysanthemum 1908

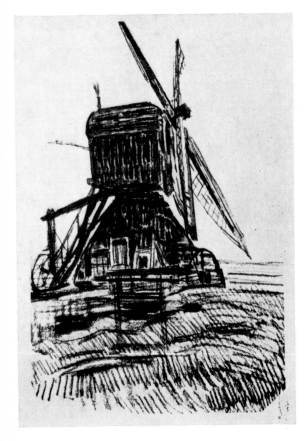

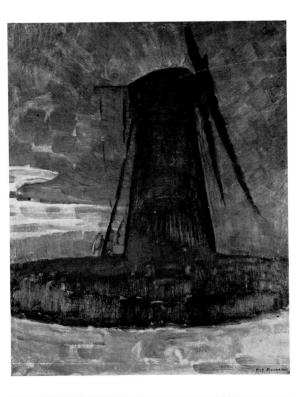

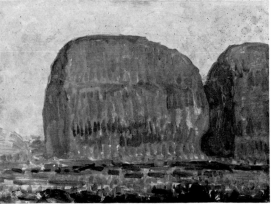

28 Study for a windmill 1908

29 Windmill at Domburg 1909

30 Hayricks 1909

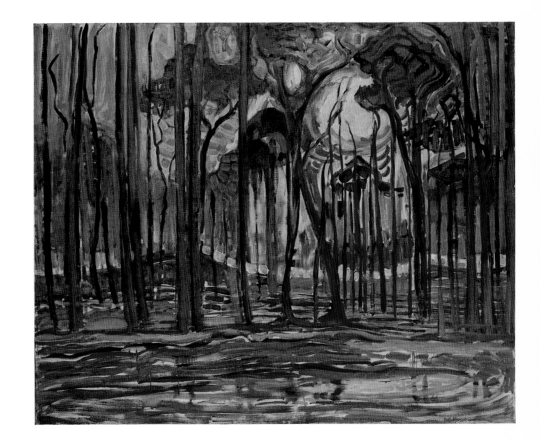

31 Woods near Oele 1908

32 "Spring" 1908
33 Portrait of a woman 1908?

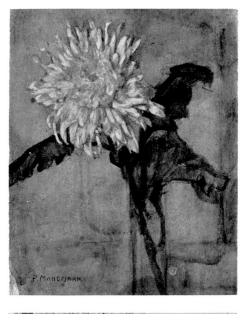

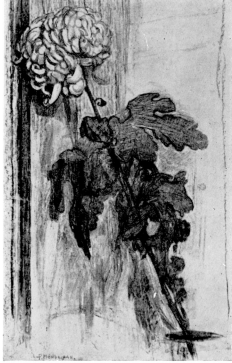

34 | 35
| 36

34 Praying child 1908
35 Chrysanthemum before 1911?
36 Chrysanthemum about 1909

37 "Evolution", triptych 1910/11

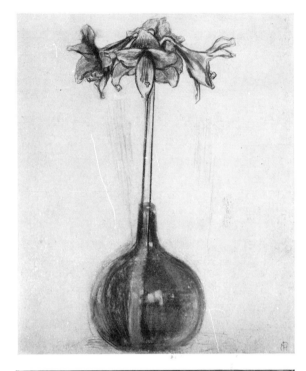

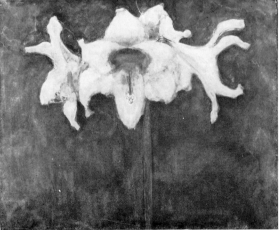

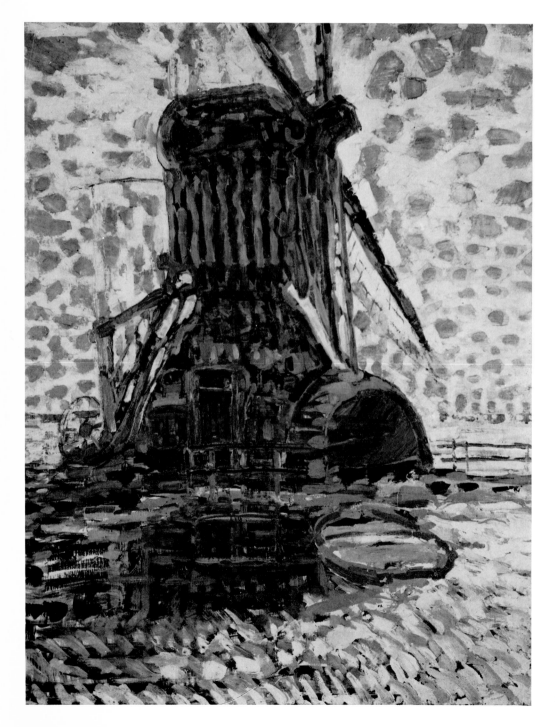

41 Windmill in the sunlight 1908

A more abstract approach

```
N | O
------
  | P
```

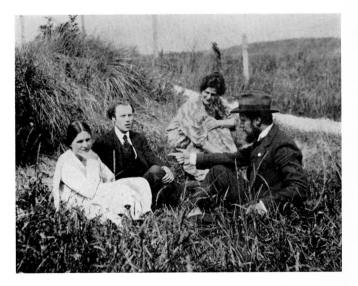

If we look at the pictures from the Domburg period, we can learn a great deal about Mondrian's development as a painter. Each of the five large groups of subjects from those years reveals a gradual and in fact quite astonishing pattern of evolution. These are: the tree pictures, the lone tower (the "Lighthouse at Westkapelle" or the tower of the church at Domburg), the façade of the church at Domburg, a series of pictures of windmills and, finally, the dune pictures.

Before discussing these five groups in greater detail and attempting to demonstrate a logical line of development running through the various drawings and paintings belonging to them, I must stress one point.

None of the pictures are dated, and all we know is that they were painted at Domburg between the summer of 1908 and the autumn of 1910. So it is quite likely that my chronological arrangement of them is not correct. I have already shown how dangerous it is to map out different phases of development without being able to supply any solid proof in support of them. We can definitely assume that Mondrian's work progressed and evolved rather erratically. But that does not prevent us from trying to arrange the pictures in order retrospectively in such a way as to bring out the pattern of growth and maturation evident in them. This arrangement will, of course, give a rather schematized picture of the natural growth process.

In our examination of the various groups, we shall start with the mill pictures. They come nearest to the Fauvist style and so form the best link with the pictures produced at Oele. The "Windmill at Domburg" looms up like some ghostly shape, and the scene around it is merely suggested and not painted in detail. It stands out against the sky symbolically, like some kind of warning or exhortation, and that was what it was intended to be. It is not just a representation of a mill. This is immediately clear to us if we compare the picture in question with the "Windmill in the Sunlight." Here Mondrian comes much closer to reality. This is a real mill, and he has attempted to use the new Pointillist style of painting to convey a deeper sense of the true effect of sunlight on a landscape. Unlike the picture of the "Windmill at Domburg," it is not a ghostly fantasy, but a portrayal of a perfectly real building, evoking a sensation of pure, unadulterated *joie de vivre.* This joyous mood is typical of the Domburg pictures. Mondrian probably felt happier and more at home when he was with Marie Tak van Poortvliet and Jacoba van Heemskerck and their group than in any other period of his life.

His rendering of the four other subjects also reveals a thoroughly positive approach. The pictures of church towers, in particular, indicate the strength that Mondrian felt growing up within him during those years. The towers and the mill pictures have one curious feature in common. The angle adopted in all of them gives the impression that they are leaning slightly backwards. That is the view we would in fact get if we stood looking up at these tall, massive buildings.

The sensitive drawing of the lighthouse indicates that this group of subjects is based on the naturalistic approach. But, as mentioned above, the angle from which it is viewed makes this stone giant seem even larger and mightier than it really is. This is a magnificent drawing, executed with confidence and feeling — a drawing in which we see a competent artist expressing the insignificance of man face to face with such a monumental structure. The whole series is derived from this drawing. Mondrian went back to the lighthouse and the church tower at different times of day. He studied them in the morning sunlight and in the full glare of the noonday sun, as dusk was falling, and in darkness. So we find something rather similar to the grandiose series of pictures created by Claude Monet, who painted the façade of Rouen Cathedral again and again in every kind of light. The comparison is not, however, apt in all respects. Monet used a single technique for his entire series of pictures, whereas Mondrian was always testing out different methods of painting his subject, trying to discover the most appropriate technique for each variation in the light. For towers standing in the sunlight he chose the Pointillist method, and to evoke a characteristic evening mood he used vigorous brushwork and built up his picture from large color planes, very much in the style of the Expressionists. Instead of creating a violent pattern of short, fierce strokes of pure color to give the effect of light playing and splashing over the tower, he applied heavy shades of violet, red, and blue, and also black, and built the tower up into a symbolic form far removed from reality. We see the same thing happening here as in the "Windmill at Domburg," where the actual building served merely as a framework for a powerful color composition charged with intense emotion.

I have already mentioned the fact that throughout his life Mondrian painted trees to express his deepest feelings. Until he turned to a purely abstract form of representation, trees appeared again and again in his work. At this point it might be a good idea to look back once more at Mondrian's early years, as well as forward to his achievements after the Domburg period, because his artistic development can be clearly traced from a study of his various drawings and paintings of trees. We saw that around 1900 he was not attracted by the individual solitary tree, but by clumps or rows of trees. I contrasted this phase with his subsequent choice of a lone tree, standing entirely on its own, as his dominant motif. I interpreted this contrast as a sign that Mondrian was coming to realize that it was up to him to make his own way in the world of art.

Whatever the truth of the matter, his clumps and lines of trees began around 1905 to express true feeling. Bathed in the muted light of evening or veiled in mist, these trees were painted in brownish greens and intense, sparkling blues that combined together to form a whole, with the strong color standing out and representing, as it were, the skeleton. Then around 1907, groups of trees were replaced by pictures of a single tree. At this time, Mondrian's work was still quite naturalistic. He

sketched a sturdy trunk, and the huge top of the tree was only roughly triangular. In his later work the trunk remained, but the upper part was metamorphosing into a series of sinuous branches with a swirling mass of leaves, forming a complete triangle and so verging on the abstract. Here too Mondrian tried to find the most appropriate method for painting his subject. The series of so-called "Blue Trees" still reveals close connections with Pointillism, but this technique was now being used in a highly individualistic manner. We still find short, fierce brush strokes, and no effort has been made to reproduce what the artist actually observed in nature.

With the "Red Tree," painted in 1910, Mondrian made a break with the past. This painting combines all the features he had met with in French Fauvism and German Expressionism, but he handled them in his own way. He had severed his contacts with what had gone before, and when he reverted to the tree motif in the following year, it looked completely different. He had become acquainted with Cubism, and that constructive form of painting, with its extremely sparing use of color, attracted him to such an extent that after the "Red Tree" his tree series took on an entirely new appearance. He used nothing but monochrome grays and browns, and the pattern of lines bore only a distant resemblance to real trees. Mevrouw Elout-Drabbe, one of his Domburg friends, owned a superb chalk drawing, now on display in the Gemeentemuseum in The Hague. I feel that this drawing marks the starting-point in the new tree series. It already contains all the characteristics of the Cubist works although the structure of the tree is still clearly based on its prototype in nature. But in the "Gray Tree" the natural sweep of the branches has been schematized in the Cubist manner. It is still recognizable as a tree, but it has been turned into an abstract pattern of lines, intensified by the use of color planes. It is, in fact, an autonomous creation — a product of the mind. Advancing in this direction, Mondrian took the final step when he painted the almost completely abstract "Flowering Appletree."

But I am getting ahead of my story by dealing with developments that occurred well after the Domburg period. We must now go back to the other series of pictures produced there, i. e. the dunes and the works inspired by the west front of the church at Domburg. In the dune series we can observe the same pattern of development as in the case of the lighthouse and the church tower, although the subject is different. The first views of the dunes are still presented in the Pointillist manner, but the later ones, in which the dominant color is a strong, luminous blue, are composed in such a way that the large surfaces representing the dunes and the sea are made to balance each other. So here too we find that the artist's perception and observation of nature have been replaced by a more intellectual approach.

In the series depicting the front of the church at Domburg the process of development has advanced still further. Mondrian presumably brought a number of more or less naturalistic drawings and oil sketches of that church back to Amsterdam in 1910 on his return from Domburg. Thanks to the spiritual and intellectual maturity he had acquired there, he used these subjects in Amsterdam to evolve a new pictorial form. His first encounter with pictures by the French Cubists at exhibitions must have made a strong impression on him and helped to determine the direction in which he would travel. His link with the Cubists had been established by Conrad Kickert, who moved permanently to Paris in 1910 and was at once admitted into the Montparnasse group of Cubists, to which Fernand Léger and Le Fauconnier belonged. From there he managed to keep up his contacts with the Amsterdam artists. At the end of 1910 the *Moderne Kunstkring* was established in Amsterdam, with Jan Toorop as its president and Conrad Kickert as the secretary. Jan Sluyters and Piet Mondrian served on the committee. The work of the French Cubists was repeatedly shown at the exhibitions held by that society until the First World War. So we definitely know that Mondrian had a chance of studying the works of the Cubists and becoming familiar with them after that date.

But he did not slavishly copy the Cubists. He combined what he had learned at Domburg with Cubist ideas and created a form that was entirely his own. Here the Domburg church façade continued to provide him with inspiration. We are lucky enough to possess a fairly complete series of drawings, all of them depicting that subject. So we can follow the progress of Mondrian towards Cubism — his own particular version of Cubism — almost step by step. Two vital points emerge if we take a close look at Mondrian's treatment of the various parts of the façade, i.e. the wall surfaces pierced by Gothic window openings and the door itself, framed by two mighty buttresses. First, when producing his somewhat abstract version, he completely abandoned perspective, and so an autonomous pattern of lines was evolved within the two dimensions of the flat surface. Second, he often set the composition inside an oval. The first point we have mentioned certainly represents the logical continuation and end-result of all the work he had previously done. The oval can, however, be interpreted as direct proof of his contact with the French Cubists, who were the first to abandon, quite definitely and intentionally, the rectangle as the traditional picture form. The Cubists were trying to create independent works of art, absolutely free from the limits imposed by mere imitation of reality. The rectangular picture still conveyed the illusion of a view seen through a window, and their abandonment of that particular form represented one aspect of the aim they were setting out to achieve. I do not think that the oval form was invented independently by Mondrian, but this possibility cannot be completely ruled out. Again and again we find instances of ideas cropping up simultaneously in different places, quite independently of one another. We shall come across a good example of this later on, when we compare Dutch Neo-Plasticism and Russian Constructivism and the parallels existing between them.

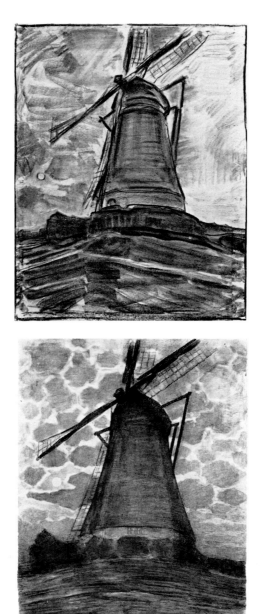

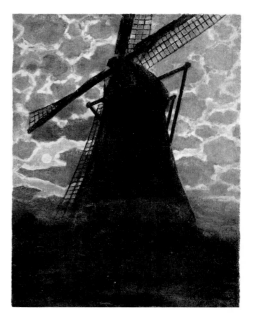

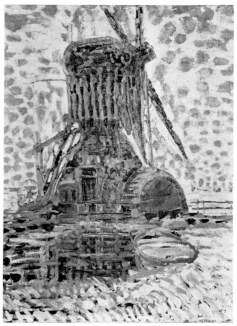

42 | 44
43 | 45

42 Windmill in the moonlight I
about 1908/09

43 Windmill in the
moonlight II about 1909/10

44 Windmill near Blaricum in
the moonlight about 1916

45 Windmill in the sunlight
1908

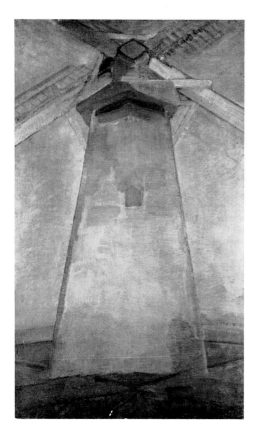

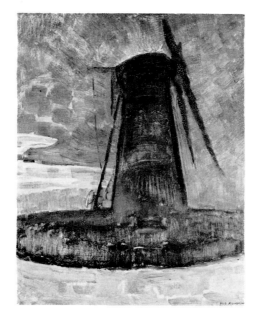

46 Windmill at Domburg (The red windmill) 1910/11
47 Windmill at Domburg 1909

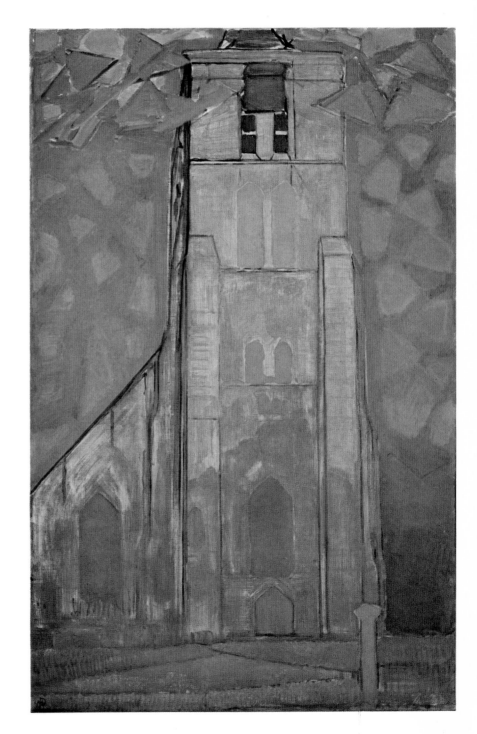

48 Church tower at Domburg 1910/11

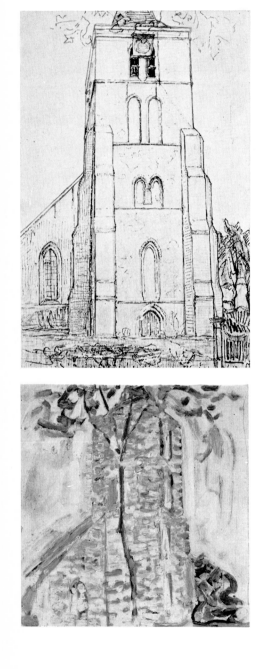

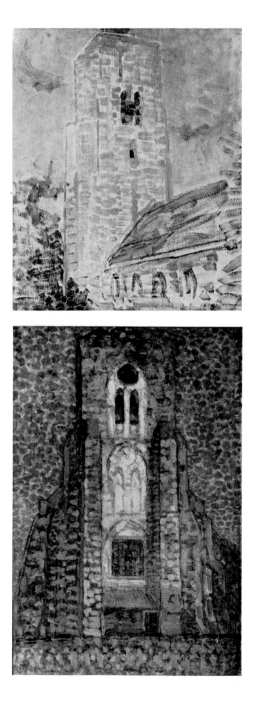

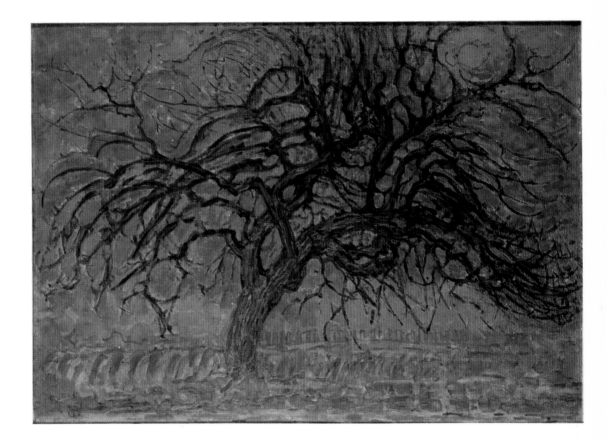

53 The red tree 1908

49 | 51
50 | 52

page 56:

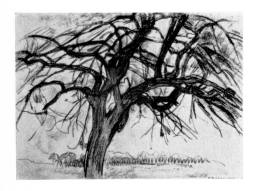

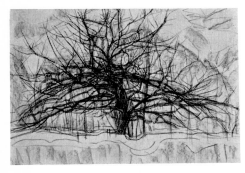

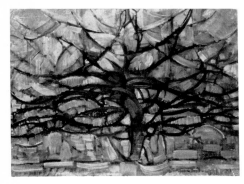

54 Tree I about 1909/10
55 Tree II 1912
56 The grey tree 1912

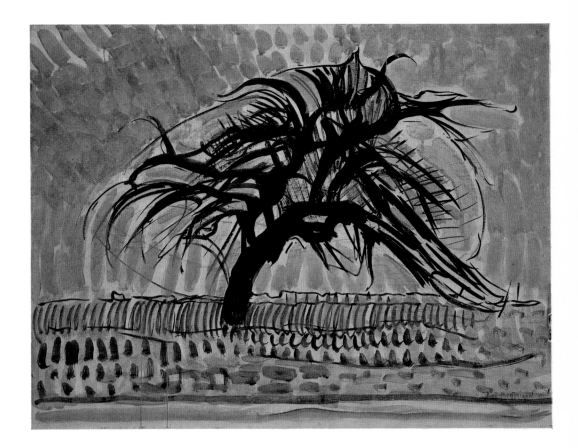

57 The blue tree about 1909/10

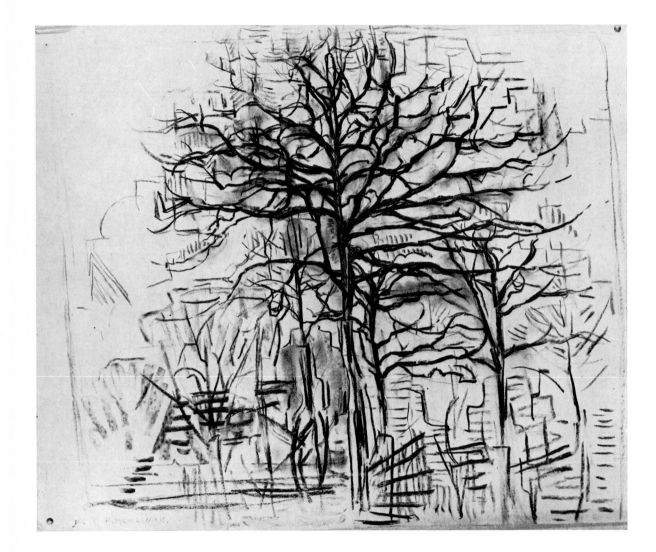

58 Sketch for trees II 1913

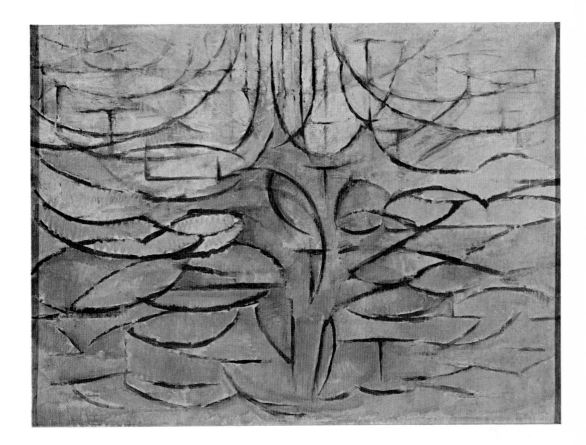

61 59 Flowering appletree 1912

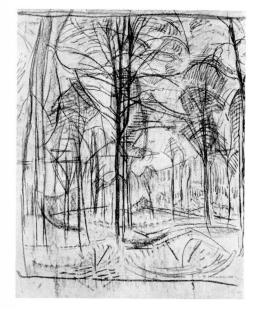

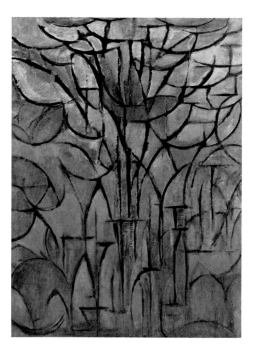

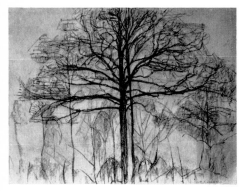

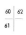

60 Black crayon sketch of trees 1912

61 Black crayon sketch of a tree 1912

62 Tree 1912

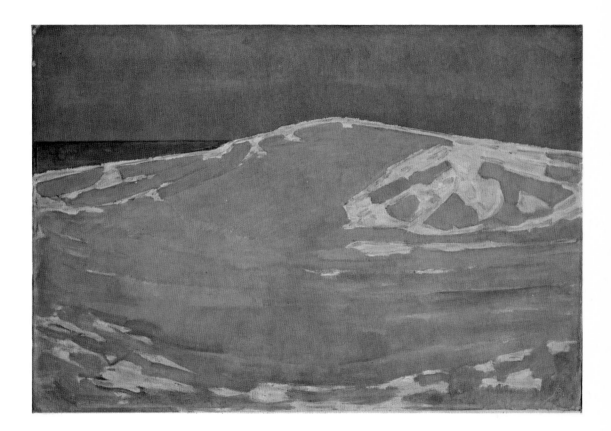

63 Dune V 1909/10

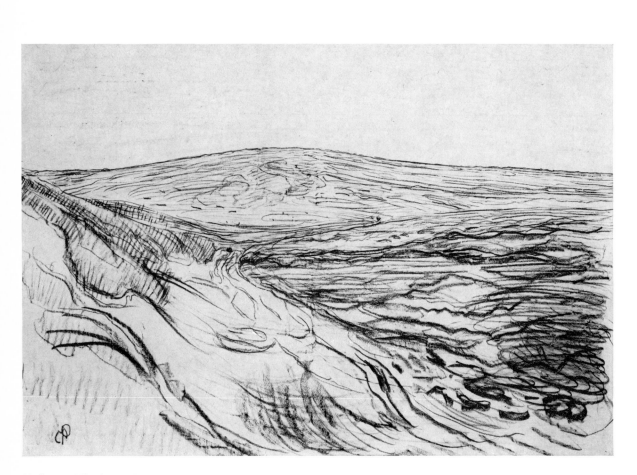

64 Dunes at Domburg 1911

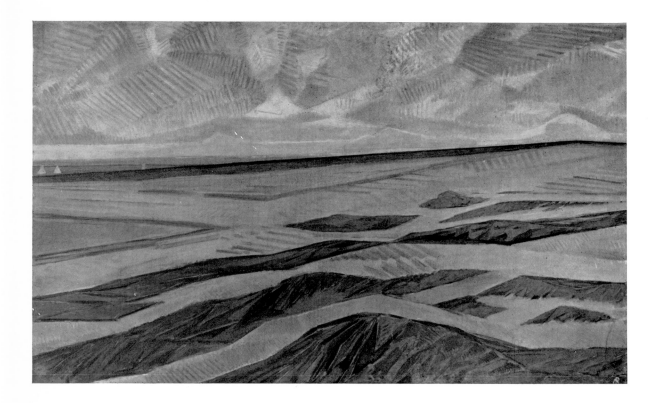

71 Dunes 1910/11

Cubism and the prelude
to abstraction

Q View from the window of the studio in the Rue du Départ, Paris (photo)
R Pencil sketch of this view 1912
S The picture called: Oval composition "KUB" envolved from this sketch 1913/14

```
Q | S
-----
R |
```

page 70:

T Pencil sketch for the "Blue façade" 1914 (Museum of Modern Art, New York)
U Self-portrait 1918. Gemeentemuseum, The Hague (on loan from S. B. Slijper)

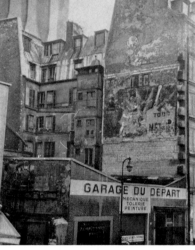

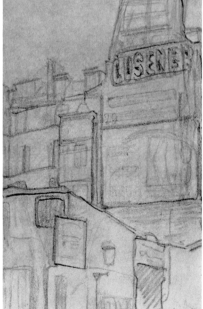

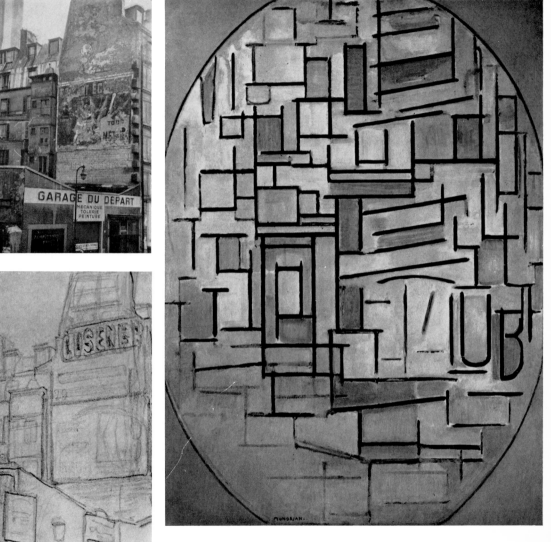

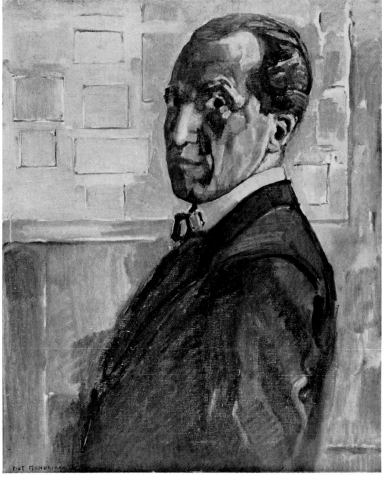

While elaborating on the sketches of the façade o the church at Domburg, Mondrian finally arrived at complete abstraction. These drawings and, above all, the paintings, now in the Kröller-Müller Museum at Otterlo, have been referred to as the "plus-and-minus" series because of the external appearance of those tense patterns of lines. It is a masterly series, charged with poetic eloquence and a dynamic quality that is completely different from the very static products of French Cubism. In these pictures Mondrian was for the first time expressing himself with absolute freedom in a pictorial language that was entirely his own. So they mark the first real climax in his career and at the same time a peak in western European art as a whole.

Mondrian did not follow up this new line of development until he had become more intimately acquainted with Cubism in its country of origin, France, and had himself tried out that particular style of painting. He had an opportunity of doing so when at the end of 1911 he accepted an invitation from Conrad Kickert to visit Paris. He took up his abode at 26 rue du Départ, where Conrad Kickert and another Dutchman, Lodewijk Schelfhout, were also living. Kickert introduced him to the Cubists of Montparnasse. But, curiously, Mondrian's Cubist pictures do not show any connection with that group. Instead, he followed the Cubists of Montmartre, the best known of whom were Pablo Picasso and Georges Braque.

A review by Guillaume Apollinaire in 1913 of the 29th *Salon des Indépendants* indicates that Mondrian was an outstanding figure even in that very French setting. Apollinaire refers to: "The highly abstract Cubism of Mondrian — he is a Dutchman and one shouldn't be surprised that Cubism is already represented in the Amsterdam museum; here people mock the young painters, but there the works of Georges Braque, Picasso, etc., are shown alongside Rembrandt. Although Mondrian takes his inspiration from Cubism, he does not imitate the Cubists. It seems to me that he is influenced by Picasso, and yet his personality remains entirely his own. His trees and his portrait of a woman display a very sensitive intellectualism. That form of Cubism appears to me to take a different direction from that of Braque and Picasso..."[4]

Apollinaire, the friend of Picasso and Braque, did a great deal to awaken interest in Cubism, and this is yet another instance of his sharp critical insight and perception.

While Mondrian continued to work in Paris in his own particular style, as Apollinaire had noted, he also contrived to paint a few pictures in the manner of the Montmartre Cubists, as mentioned before. A "Nude," a "Bridge Study," and a "Landscape" are the most outstanding of these. They are undoubtedly striking, but I must confess that I personally do not care for them very much. They clearly indicate that the style of the French Cubists was not in tune with Mondrian's true character. These pictures seem a little forced and unnatural, the coloring is muddy, and the whole effect is unconvincing. But

their real interest lies for me in the fact that they reveal the serious attention Mondrian was paying to the Cubism then being practiced in Paris.

At the same time, he was painting a series of Cubist pictures in his own particular language. These are a continuation of his tree series and present a rather abstract version of the view from his studio window. Here we see once again the full dynamic power of Mondrian and his great ability as a painter. Interlocking rectangular shapes, worked in gay, vivid colors, have been inserted in the oval form of one of these window pictures, owned by the Gemeentemuseum in The Hague. On the right-hand side we can see the letters KUB. Professor Robert Welsh of the University of Toronto has found a photograph taken from the window of the studio in the Rue du Départ. There is also a naturalistic drawing executed by Mondrian himself — at present in the Sidney Janis Collection in New York — which captures the very same view of the wall facing his studio. Both of them reveal the origin of those mysterious letters. There happened to be a poster on the wall advertising beef extract cubes with the brand name "Kub." There are also a number of other drawings showing walls of buildings and church façades which Mondrian later converted into abstract pictures.

I have already mentioned the "Flowering Appletree" subject, among others. It is worth noting that Mondrian reverted to clumps of trees at that particular time. I am rather reluctant to venture into the field of psychology. But his abandonment of the solitary tree and his return to pictures containing clumps of trees have perhaps some connection with the group of congenial friends he met in Paris. I would like to quote a remark made by one of his Paris friends, the Dutch composer Jacob van Domselaer. Michel Seuphor asked him what Mondrian was working on during his first stay in Paris. "Trees," he replied. "Nothing but abstract trees!" We are fortunate enough to have several of these tree pictures. With clean, light touches of yellow, sky blue, green, and brick red he used the rising trunks to conjure up an abstract pattern before our eyes. They express great dynamic intensity and are among the purest and most unaffected creations of Mondrian. I have often seen people, especially women, pause in front of these paintings with a cry of sheer amazement. Anyone whose knowledge of Mondrian is confined mainly to his severe and restrained Neo-Plastic compositions cannot but feel surprised when he suddenly comes face to face with the chief works from that period, which are so musical and poetic. I am using the term "musical" quite intentionally and shall be referring later on to the special part played by music in Mondrian's life. I shall merely quote here a passage from his pamphlet "Le néo-plasticisme," written in 1920: "The new spirit demands, in music as in other fields, a plastic equivalent of the individual and the universal in terms of a balanced proportion."[5]

Mondrian's working method comes out very distinctly in two paintings, both of them representing the theme "Still Life With Ginger Jar." The first still life is securely attached to reality. The subject portrayed is clearly recognizable — a corner of the painter's studio, with unused canvases, a tumbler

of water, a few paint-pots, and some sheets of paper, all grouped around a ginger jar. This is a very satisfying picture with its intense and yet restrained coloring, in which gray-blue and brown are the predominating hues. The other still life is a variation and abstraction of the same theme, but it is still identifiable in the midst of the pattern of lines, which verges on the abstract.

These, like the pictures we have already mentioned, show the extent to which Mondrian's stay in Paris influenced his work and the direction in which he was moving. He was now a painter of some note. This is shown by the quotation from Guillaume Apollinaire and the invitations Mondrian received to send pictures to the *Erster Deutscher Herbstsalon* in Berlin in 1913 and the *Salon des Indépendants* in Paris. As we have already seen, Mondrian was exhibiting work regularly in Amsterdam in the *Moderne Kunstkring.* But in spite of wide acclaim and recognition, he was still worried about earning a living.

Mondrian remained poor throughout his life, so he should be commended all the more warmly for not deviating from his chosen path, even though he realized that life would have been easier if he had followed the dictates of artistic fashion. When his funds ran out completely, he was sometimes forced to paint a portrait or a flower composition in order to keep body and soul together. But in spite of his straitened circumstances, he felt very much at home in Paris. He would probably have stayed on there permanently if he had not been called to his father's sick bed in July 1914. He had contemplated merely a brief stay in Holland, but the First World War broke out and he was unable to leave. He had to wait until 1919, shortly after the Armistice, before he could see Paris again.

4 In the magazine "Montjoie," March 18, 1913: "Le cubisme très abstrait de Mondrian — c'est un Hollandais (on ne doit pas se montrer trop surpris de ce que le cubisme ait fait son entrée au Musée d'Amsterdam; alors qu'ici on se moque des jeunes peintres, là-bas les oeuvres de Georges Braque, Picasso, etc., sont exposées a coté de Rembrandt); Mondrian tout en s'inspirant du cubisme n'imite pourtant pas les cubistes. Il me semble qu'il est influencé par Picasso, mais sa personnalité reste exclusivement la sienne propre. Ses arbres et son portrait d'une femme montrent un intellectualisme très sensitif. Cette forme de cubisme me semble prendre une direction différente de celle de Braque et de Picasso ... "
5 "Editions de l'Effort Moderne," Paris, 1920, p. 10: "L'esprit nouveau exige, dans la musique comme ailleurs, une plastique équivalente de l'individuel et de l'universel en fonction d'une proportion equilibrée."

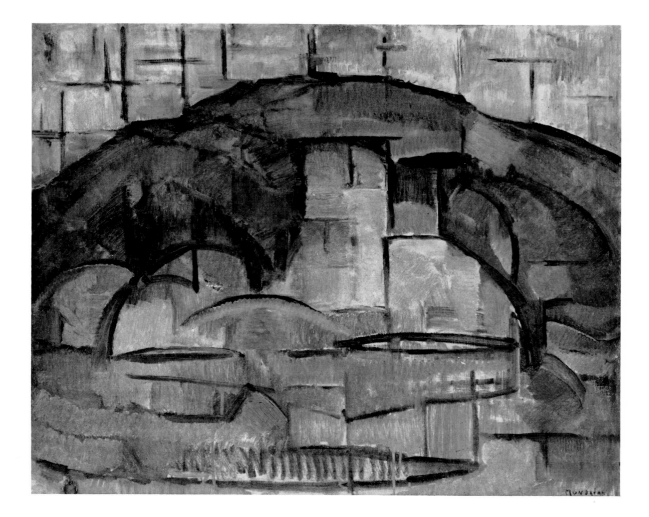

72 Landscape 1911

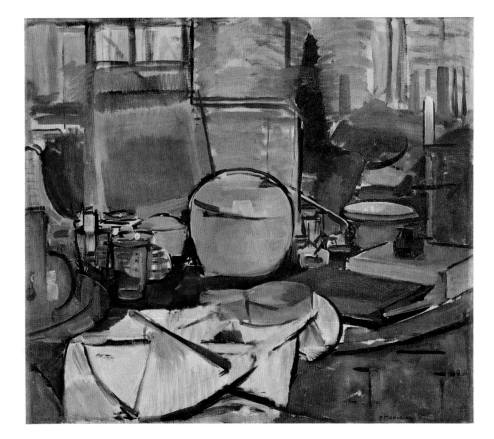

73 Still life with ginger jar I 1911

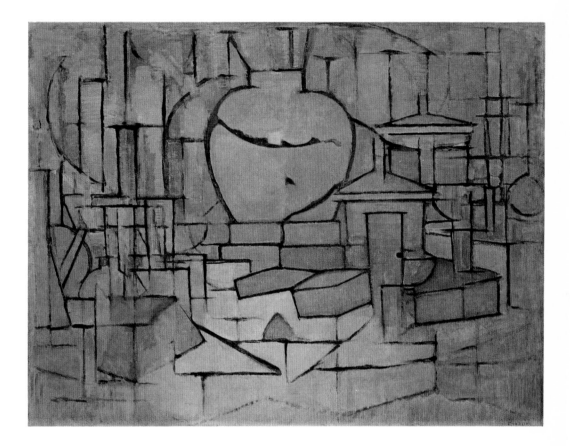

74 Still life with ginger jar II 1911/12

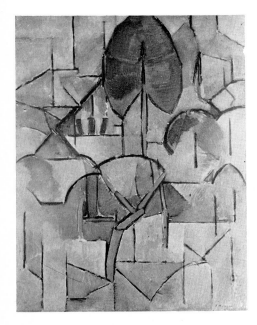

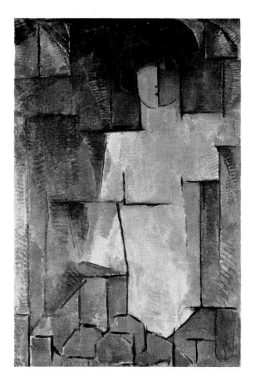

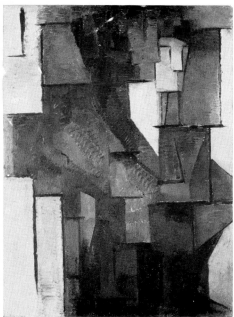

75 | 77
76

75 Landscape with trees 1911
76 Female figure 1911
77 Nude 1911

78

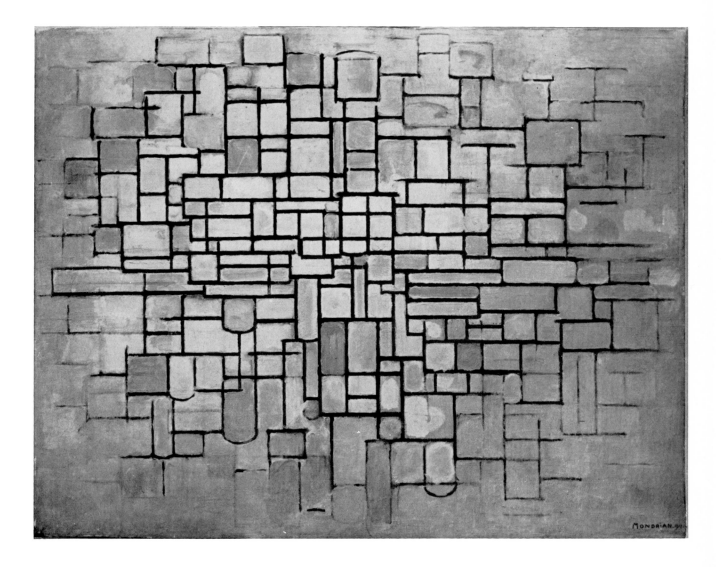

78 Composition 2 with lines and colours 1913

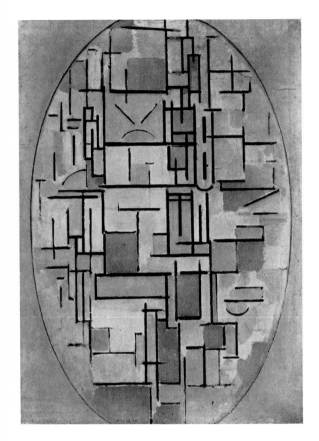

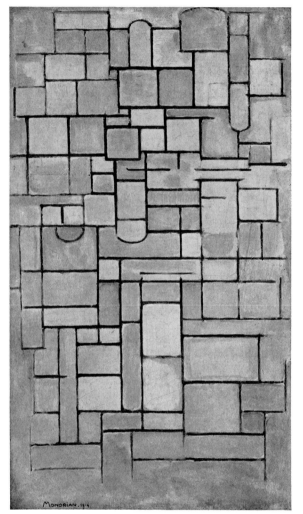

79 Oval composition 1913/14
80 Composition 8 1914

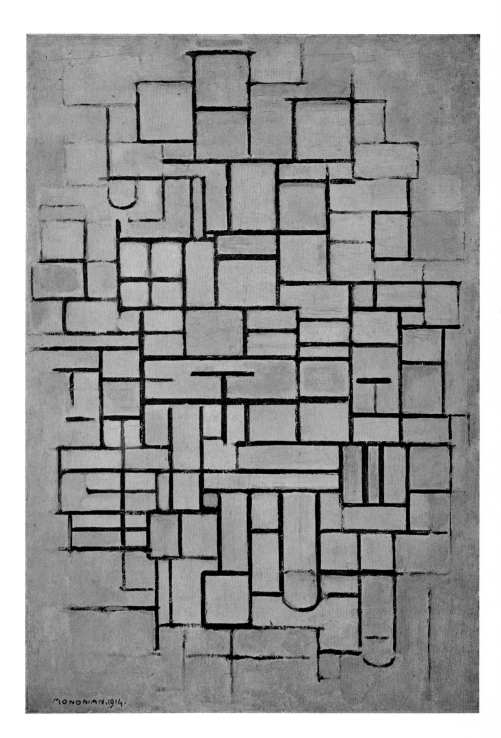

81 Composition 6 1914

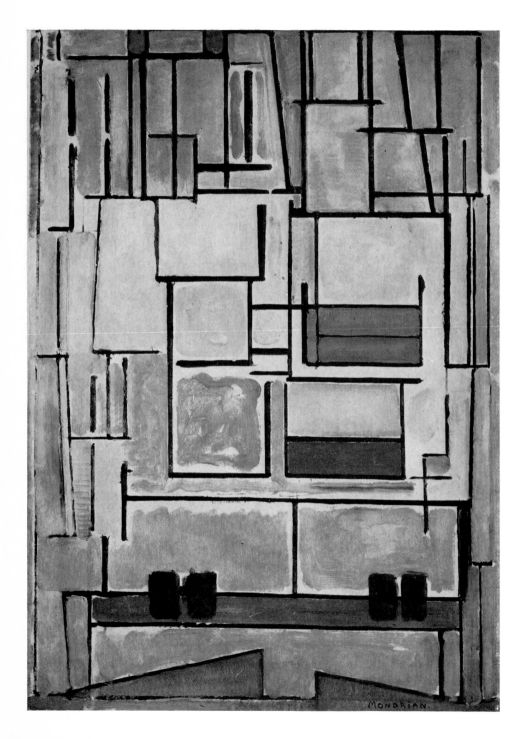

82 Composition 9 ("Blue façade")
1913/14 (see p. 70)

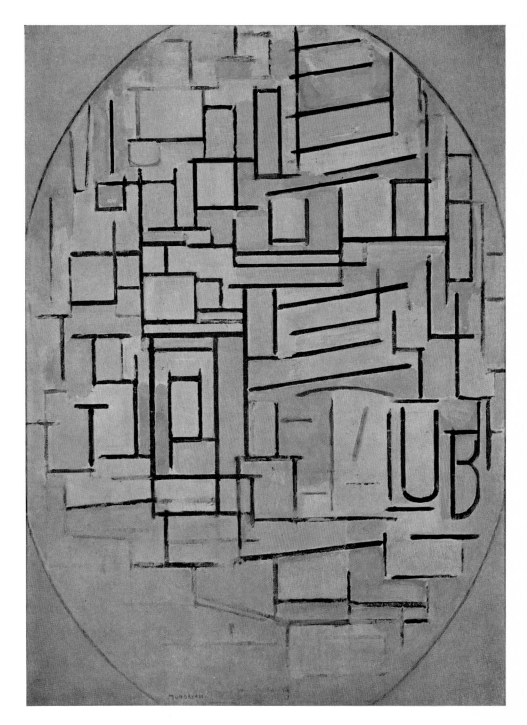

83 Oval composition: "KUB" 1913/14
(see p. 69)

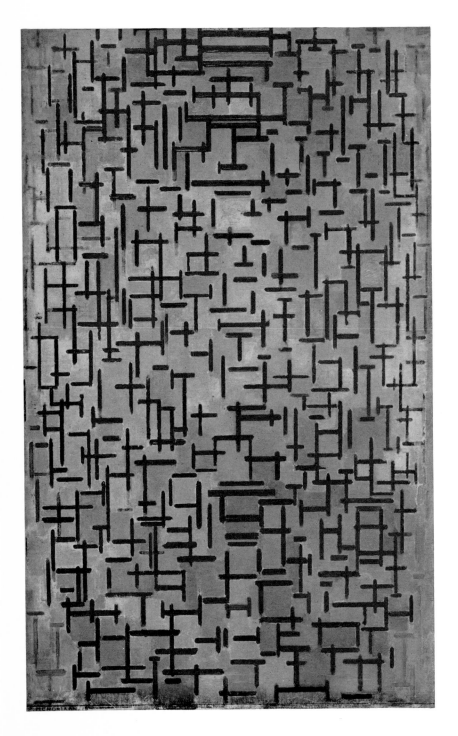

84 Composition 1916

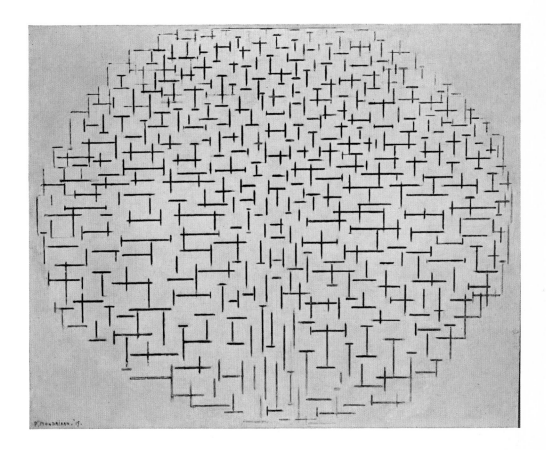

85 Composition 10 (Pier and ocean) 1915

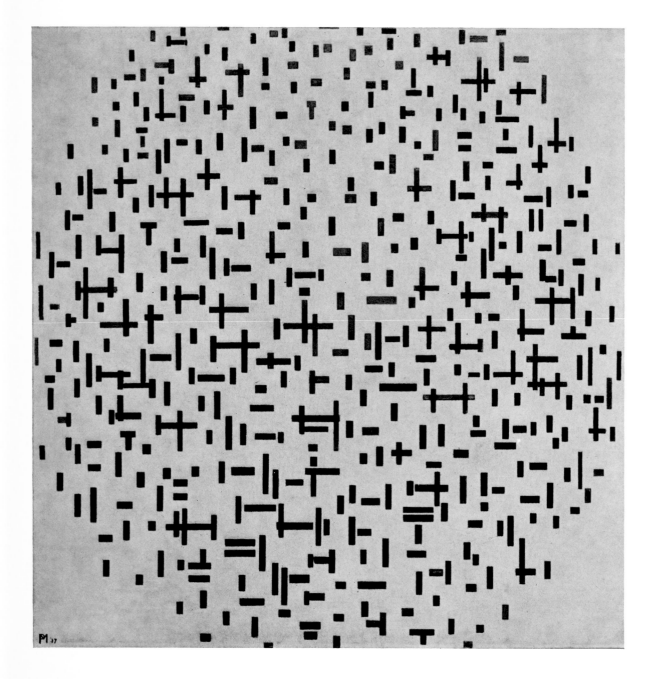

86 Composition in black and white 1917

The "Stijl" period

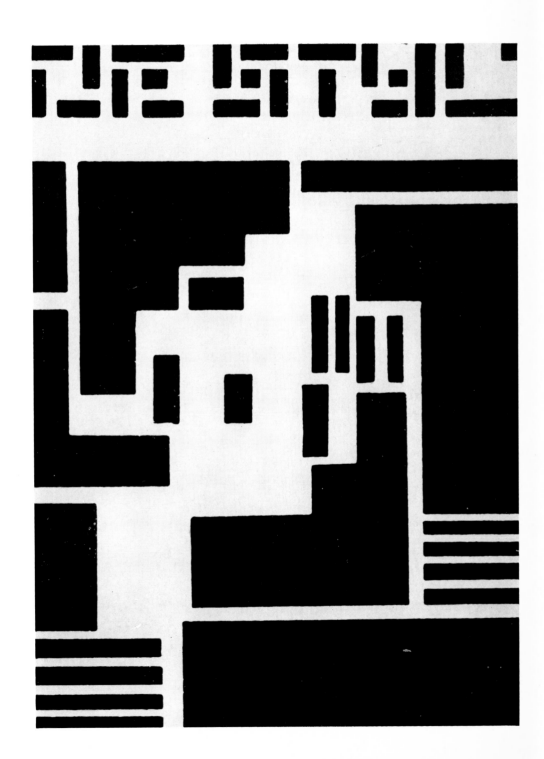

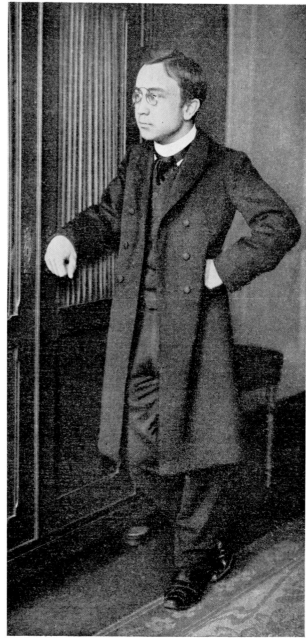

W
X | Y

How Mondrian must at first have chafed at his enforced stay in Holland! Little did he know that the most vital phase in his whole career was about to begin. First he went to Domburg. Shortly afterwards, towards the end of 1914, he moved to Laren, near Amsterdam, then a favorite spot for artists and scholars. There he met four men destined to change the whole course of his life. The first of these was Dr. J. Schoenmaekers, a philosopher who had long been a Roman Catholic priest. Dr. Schoenmaekers had made a detailed study of mathematics and had written a book on the subject entitled *Beginselen der Beeldende Wiskunde* (The Rudiments of Figurative Mathematics), which was published in Bussum in 1916. That book, like his *Het Nieuwe Wereldbeeld* (The New Image of the World), brought out in Bussum in 1915, made a deep impression on Mondrian, and he would not rest until he had made the author's acquaintance. Like the book by Krishnamurti which was his constant, lifelong companion, he also dipped into these two books again and again.

From their very first meeting, he and Dr. Schoenmaekers became firm friends. They met several times a week for long conversations, and in the course of these, Mondrian's own individual theory of art and the universe, which was to be his guide for the rest of his life, gradually took shape. A great deal of what he later put into his theoretical writings came from Schoenmaekers, who acted as a kind of catalyst, enabling Mondrian to express his own ideas in clear and definitive form. The essence of the theory was the indissoluble connection between art and the universe, with art making its contribution toward a Utopian future — a universe where perfect harmony would reign.

His meeting with Salomon Slijper was also an extremely important event in Mondrian's life. Slijper had been brought up in a decidedly Jewish environment and had acquired a simple philosophical attitude to life that was at the same time searching and profound. It came so close to Mondrian's own outlook, which was founded on Calvinism, that the two men felt strongly drawn towards each other from the very start.

Until the Second World War, Slijper was one of Mondrian's friends — van den Briel was another — to whom he could always turn when he needed spiritual guidance or material help. Like van den Briel, Sal Slijper is unwilling to publish his correspondence with Mondrian. Both feel that it is of too personal a nature to be disclosed to outsiders. I have had an opportunity of reading some of these letters and very much regret that I am not at liberty to quote from them. The few that I saw did, however, convince me that his conversations with Salomon Slijper had an important effect on Mondrian's spiritual and intellectual development.

In 1915 Mondrian made the acquaintance of Theo van Doesburg, who introduced him to the painter Bart van der Leck. The "Stijl" enterprise was to bring him into close contact with van Doesburg in the years to come. Mondrian's association with Bart van der Leck also had a decisive impact on his

evolution as a painter. For some years van der Leck had been experimenting with the geometrical division of color planes. Mondrian had been contemplating something similar. So his meeting with van der Leck finally triggered the next phase in his painting career, which culminated in Neo-Plasticism. There was no intrinsic or subjective relationship between the works of the two artists. Mondrian's Neo-Plastic pictures express deep spiritual excitement. The aim of van der Leck was to capture the world around him by purely pictorial means and present it as an abstract pattern. In other words, Mondrian's abstractions stemmed from deep inside him and those of van der Leck from his observation of reality. Until 1916, as we have seen, Mondrian too had based his work on reality. It was only the deepening of his spiritual and intellectual awareness, brought about by his contacts with Schoenmaekers, Slijper, and later Theo van Doesburg, that caused the change to take place. He broke away completely from his earlier style of painting and from then until the last years of his life, he endeavored to paint in the Neo-Plastic manner, from the mind, using pure form as far as possible.

Soon after their first meeting, Mondrian and Theo van Doesburg realized they were both traveling in the same direction. Both were anxious to help the world at least a short way along the road that would lead ultimately to complete harmony of the spheres, and equilibrium between mind and matter. They wanted to put their ideas into practice and decided to form a group of artists. The mouthpiece of the movement was to be a magazine called "De Stijl." J. J. P. Oud, whom van Doesburg met in Leiden after moving there from Laren, was a young architect with similar views. These three founders of the "Stijl" group were joined in the same year (1916) and later by other artists and architects, e. g. the architects G. J. Rietveld, C. van Eesteren, Jan Wils, and Robert van't Hof, the painter Vilmos Huszar, the poet Antony Kok, and the sculptor Georges Vantongerloo. In the early issues of the magazine, Mondrian published a series of articles presenting his own basic principles and those of the group. The first sentence loudly proclaims their convictions: "The cultivated man of today is gradually turning away from natural things, and his life is becoming more and more abstract." More specifically, he went on to say: "It is the same with art. Art will become the product of another duality in man: the product of a cultivated externality and of an inwardness deepened and more conscious. As a pure representation of the human mind, art will express itself in an aesthetically purified, that is to say, abstract form."

A comparison of Mondrian's writings with the work of Schoenmaekers clearly shows that many of the former's ideas can be traced to that philosopher. But only when they were set out in the simpler and clearer style of Mondrian did they combine to form a definite whole. His essays contain more than just a theory of art — they build up a picture of the universe, and this Utopian ideal of the universe, which art was made to serve, remained unchanged down the years. As late as March 1942 Mondrian,

then resident in America, wrote an English-language article entitled "Pure Plastic Art." It was intended as a preface for the catalogue of an exhibition called "Masters of Abstract Art," held in that year in the Helena Rubinstein Salon in New York. He expressed himself as follows: "Art is only a 'substitute' as long as the beauty of life is deficient. It will disappear in proportion as life gains in equilibrium. Today art is still of the greatest importance, because it demonstrates plastically in a direct way, liberated of individual conceptions, the laws of equilibrium."[6]

But we must return to the pictures and not wander off into Mondrian's theoretical writings.

After his return from Paris, he worked for a few years on pictures based on sketches he had brought back with him. Around 1916 he produced three paintings under the influence of Bart van der Leck and these already contain a gradually growing suggestion of Neo-Plasticism. They can be viewed in the galleries of Otterlo, Rotterdam, and The Hague. On the back of the picture from the Kröller-Müller Museum in Otterlo we find the title "Composition in Blue, B." "Blue" (pale blue) would be a more or less apt description of the coloring of the other two as well. The softly subdued intermediate tones used for the well-defined color planes, which are made to overlap one another or are scattered over the canvas in a rather loose and incoherent manner, give the pictures a gay touch of liveliness and dynamism and also poetic force. All three are dated 1917 and are transitional pictures forming a link with the following period, during which works in the pure and severe Neo-Plastic manner were produced in conjunction with the "Stijl" group.

Mondrian himself gives the following account of what happened: "As a result of continuous effort, the 'Stijl' group managed to produce a composition based exclusively on the equilibrium of pure relationships and arrived at intuitively by a combination of deepened sensitivity and higher intelligence. Although these relationships are formed in nature and in our own minds according to the same main universal laws, works of art are now expressed in a different way from nature. In present-day art we must try to convey only what is essential in nature and what is universal in man. The individuality of the artist also plays a part here and so new laws have been coming into existence. For example, the repetition that we find in natural forms is eliminated from these new works of art. The new type of composition is based on the presence of permanent oppositions, contrasting with and neutralizing one another. Lines are straight and always occur in their two principal opposites, thus making a right angle, the plastic expression of the constant. Dimensional relationships are always based on this key relationship. So the new plastic art is 'equivalent' to nature, and works of art no longer bear a visual resemblance to natural objects."[7]

We are struck here by the vigor and determination with which Mondrian defended the independent existence of plastic art, by which I mean independence in relation to the visible world around us.

He was convinced that the creations of plastic art were independent products of the human mind in just the same way as a musical composition or a philosophical essay. The status of plastic art within the whole general field of art has been debated for centuries. Renaissance thinkers, in particular, wrote long treatises on the subject, and it has remained a lively topic of discussion ever since. But never in the whole history of art has anyone carried his "sacred belief" in the autonomy of plastic art to its final and logical conclusion as thoroughly as Mondrian did in his work. I am quite deliberately using the term "sacred belief" here, as I do not think it is at all out of place. His creative work stemmed from such profound human thoughts and emotions, as this quotation from his own writings clearly indicates: "My view is that contemplation, plastic vision, has great importance for man. The closer contemplation brings us to a conscious *vision* of the unchangeable and the universal, the more the changeable, the individual, and human pettiness in us and around us, will seem futile to us.

"Man is enabled by means of abstract-aesthetic contemplation to achieve conscious unity with the universal. All disinterested contemplation, to use Schopenhauer's term, elevates man above his natural condition. The natural man does his best to improve his material condition, and to safeguard his individuality; even his spiritual aspirations are not directed toward the universal, which remains unknown. But in aesthetic contemplation the individual is pushed to the background, and the universal appears. The deepest purpose of painting has always been *to give concrete existence, through color and line, to this universal* which appears in contemplation. The new painting, which is breaking away from the natural appearance and is characterized by a more *clearly defined* representation of the universal, should be seen as a manifestation of the spirit of our age. For our age, as it reaches ever higher degrees of consciousness, becomes increasingly capable of transforming the various *moments* of contemplation into *one unique moment,* into one permanent contemplation" ("Natuurlijke en Abstracte Realiteit," III[8]).

I have now reached the most important phase in Mondrian's creative development, the Neo-Plastic period. Mondrian himself coined the term "Neo-Plasticism," which, after the quotations I have just given from his own statements on the subject, should not require any further clarification. It is not so easy to describe the pictures from that period. They contain a minimum of subject matter — black horizontal and vertical lines that always cross to form a right angle, with planes of pure color in between. Here I would like to quote Mondrian once again, so that he can tell us in his own words what these intersecting black lines were intended to convey. He wrote as follows in America about the ideas occupying his mind at that time: "Art had to attain an exact equilibrium through the creation of pure plastic means composed in absolute oppositions. In this way, the two oppositions (vertical and horizontal) are in equivalence, that is to say, of the same value: a prime necessity for equilibrium. By means of abstraction, art had interiorized form and color and brought the curved line to its maximum tension:

the straight line. Using the rectangular opposition — the constant relationship — established the universal individual duality: unity."[9] The ideas expressed here constitute the whole basis of Mondrian's Neo-Plastic work. He took it so seriously that he parted company with van Doesburg in 1925 and refused to go on working with "De Stijl." Van Doesburg championed the diagonal, as opposed to the right angle of Mondrian, and so the dynamic, in contrast to the static.

6 Printed in: Plastic Art and Pure Plastic Art and other essays by Piet Mondrian, New York, 1947, p. 32.
7 In "Cahiers d'Art," Paris, 1926, No. 7: "Un travail continu amenait le groupement à une composition exclusivement basée sur l'équilibre des rapports purs, sortant de l'intuition par l'union de la sensibilité approfondie et de l'intelligence supérieure. Bien que ces rapports se forment dans la nature et dans notre esprit suivant les mêmes lois principales et universelles, de nos jours l'oeuvre d'art se manifeste d'une autre façon que la nature. Parce que de nos jours dans l'oeuvre d'art il faut tâcher d'exprimer seulement ce qui est essentiel de la nature, et, de l'homme uniquement ce qui est universel. L'expression individuelle, issue de notre nature, apparaît déjà là. Ainsi des lois nouvelles se font jour. Par exemple dans l'oeuvre de l'art nouveau, la répétition que l'on observe dans l'apparition naturelle est annihilée. La composition nouvelle repose sur des oppositions permanentes, contrariantes et neutralisantes. La ligne en est droite, et toujours dans ses deux oppositions principales, qui forment l'angle droit, expression plastique de ce qui est constant. Et les rapports de dimensions sont toujours basés sur ce rapport de position principale. Ainsi, la nouvelle plastique est un 'équivalent' de la nature et l'oeuvre d'art n'a plus de ressemblance visuelle avec l'apparition naturelle."
8 "De Stijl," 1919, No. 10, pp. 109 ff.
9 Plastic Art and Pure Plastic Art, New York 1947, pp. 31 ff.

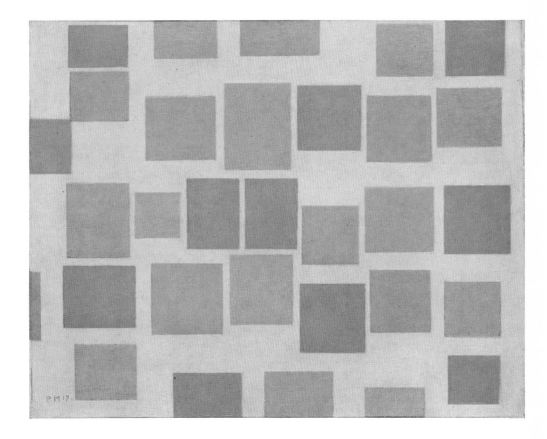

87 Composition 3 with colour planes 1917

88 Lozenge with grey lines 1918

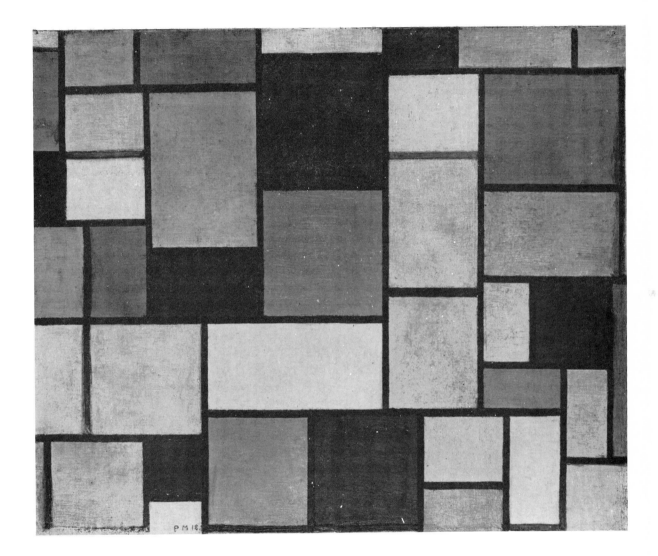

89 Composition: Colour planes wity grey outlines 1918

90 Composition: "Checkerboard", dark colours 1918

91 Composition: "Checkerboard", bright colours 1919

92 Composition in lozenge with grey lines 1919

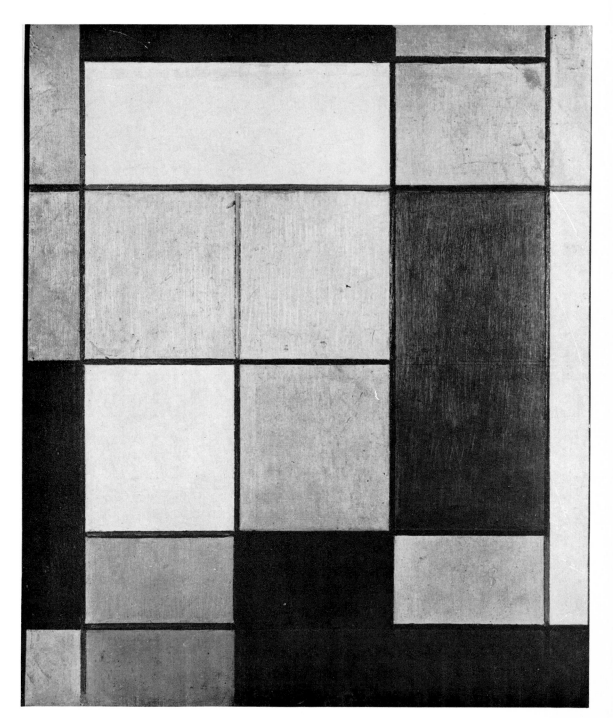

93 Composition with
 red, blue and
 yellowish-green
 1920

103

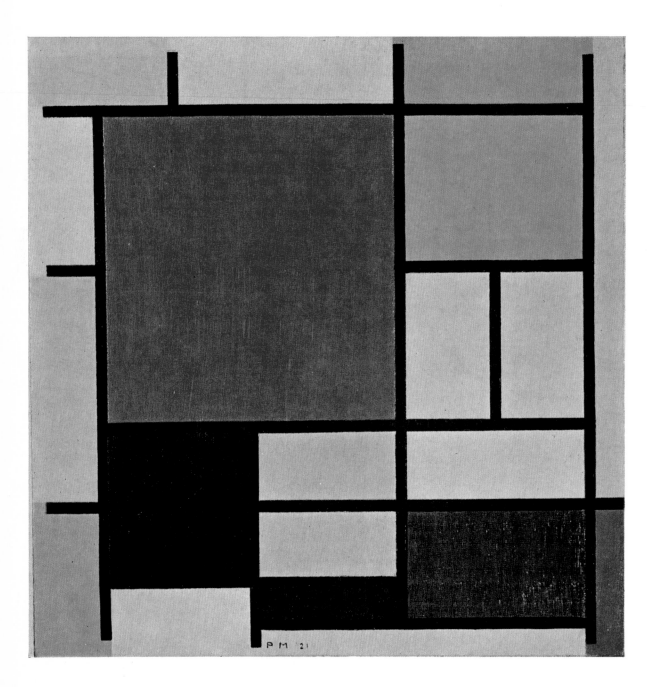

94 Composition with red, yellow, blue and black 1921

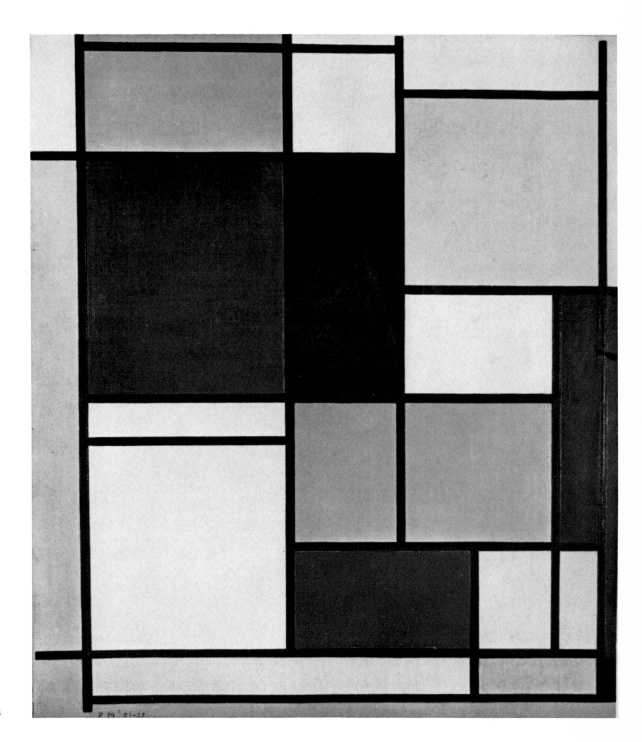

95 Tableau II 1921/1925

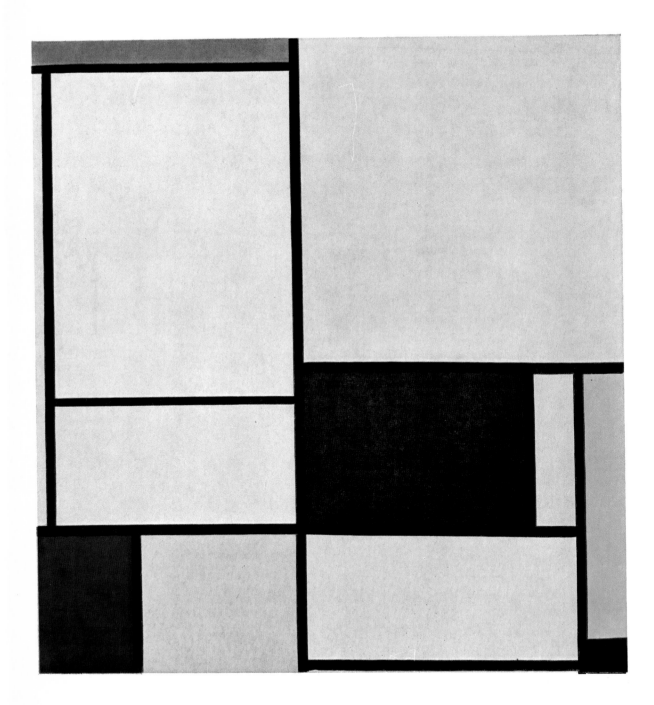

96 Composition 1921

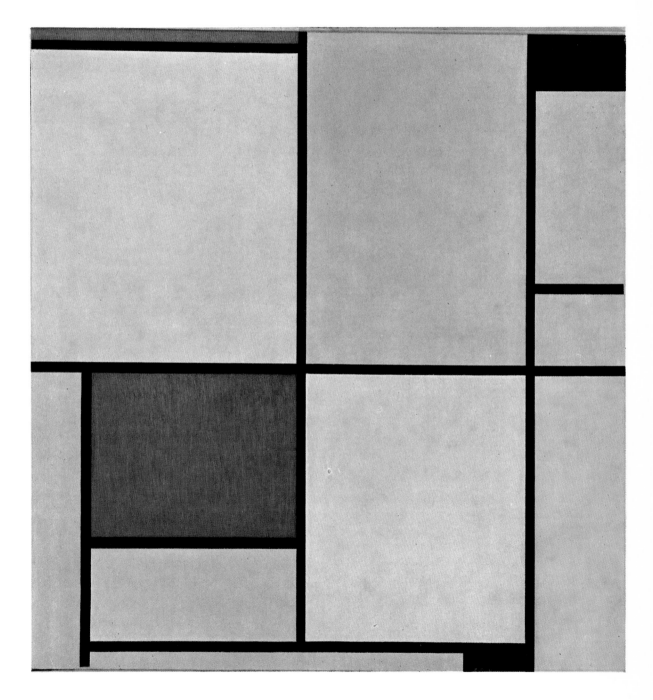

97 Composition I with red, yellow and blue 1921

98 Charcoal sketch for Tableau I 1921

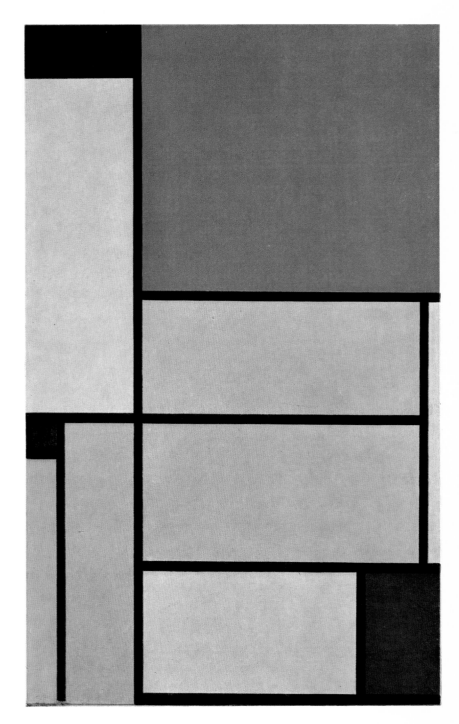

99 Tableau I 1921

The second period in Paris
Neo-Plasticism

Z The studio at 26 Rue du Départ, Paris 1926 (photo)

page 114:

A[1] Entry to the studio in Paris (photo)
B[1] Mondrian in his studio in Paris (photo)
C[1] The studio in Paris about 1937 (photo)

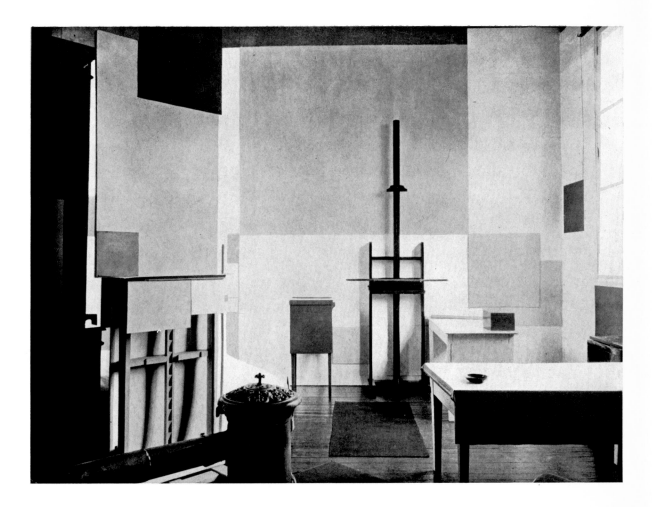

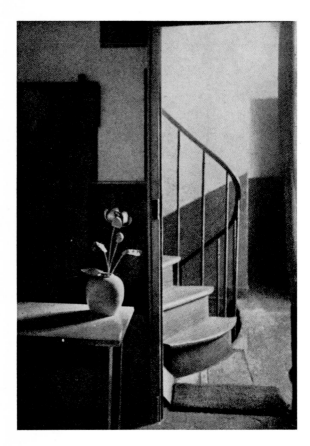

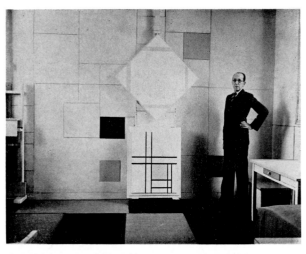

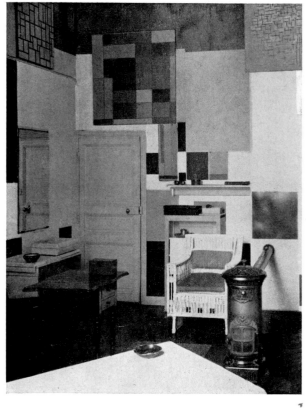

Mondrian was living again in Paris, having returned there in 1919. He stayed for a time at 5 rue de Coulmiers. Then he returned to his former abode at 26 rue du Départ and remained there until about 1936, when he moved to 278 boulevard Raspail. All these studios were situated in rather shabby houses. Michel Seuphor, a great friend of his during this second period in Paris, gives us some idea of the drab entrance leading into one of these studios. One reached the studio through a dark hall in which on a small table there was always a vase with a single flower, symbolizing "a feminine presence." Mondrian, a bachelor, was far from being unsusceptible to women, but his poverty and a number of unhappy love affairs had prevented him from forming any permanent attachment and having a wife to fuss over him. The solitary flower stood there as a touching mark of his devotion to the female sex. After going through the hall, the visitor reached Mondrian's studio, which was in itself a curiosity and a work of art. Although soberly furnished and extremely bare, it was meticulously tidy. The artist had painted the walls and the meagre furnishings in keeping with the "Stijl" principles. The walls were decorated with horizontal and vertical lines, enclosing color planes in pure red, yellow, and black. The floor was treated in the same way and the plain kitchen table was painted white, with a red drawer. The picture he was working on at the time stood on the easel and other canvases were carefully placed so as to fit in with the wall pattern.

Descriptions by his visitors (Seuphor, James Johnson Sweeney, Henry Clifford, Ida Bienert, Slijper, and Oud, the architect) and photographs give us some idea of Mondrian's environment and way of life. He himself discussed it in his "Essay in Dialogue Form" ("Natural Reality and Abstract Reality"), to which we have already referred:

Y: Your studio doesn't really surprise me. Everything here breathes your ideas. Other studios are not at all like this.[10]

Z: Most of the other painters are not like me, either. These things go together. Most painters show a preference for unmodern things, they surround themselves with old furnishings, carpets, objects, pictures.

X: And they're not wrong to do that: painters seek the beautiful, and these things are beautiful.

Z: They are beautiful, no question of that, but they are also old! We have already said quite a bit about that. As for me, I think it is difficult for an artist to strive toward a new conception of the beautiful while he continues to make his house or his studio a kind of museum of old art, often of mediocre quality. Thus he himself creates an atmosphere in which the new cannot be at ease. And the art lover imitates the artist.

I think that the present-day artist should show preference for the trend of his age in all matters. This studio expresses to some extent the idea of Neo-Plasticism. In a certain way, it shows the

equivalence of relations achieved exclusively by the elements of color and line. The shape of the studio favored this effect, for space is articulated here in such a way that abstract relations are stated in its very form. Which is more than we can say of most other studios or apartments. Our Dutch rooms are usually lacking in any kind of architectural taste. They are hardly more than spaces limited by six flat surfaces — with holes for doors and windows. Then these rooms have to be divided by means of the objects the occupant chooses to place or hang there. French rooms, on the whole, have a certain organization: some thought has been given to the woodwork, to the construction of fireplaces or stoves, to the placement of mirrors, the type of floor, etc. All this amounts to some sort of composition, such as we find sometimes in our country too, in the homes of well-to-do people. But the wall surfaces are always undivided, or divided in an unbalanced way.

Y: That's true; and how different one room can be from another!

Z: The difference is due to the distribution of space and to the use of color. We can see this, for instance, in many of the business districts of France. The various façades divide the street spatially. They are differentiated by means of white, black, or some definite color. Thus they form a composition of various colored planes expressing clear and balanced relations. A certain balance of architectonic and decorative elements also struck me at times, in our country, for instance, in the farms of Brabant.

Y: Then everything depends on the way in which a room space is divided?

Z: When a room's proportions are right, it may satisfy us momentarily, but not in the long run. For this is not enough to make it "livable." To meet such a requirement, i. e. to satisfy us continually from the aesthetic point of view, a room should not be an empty space, limited by six empty planes which are merely opposite each other: a room should be a divided space, hence a space already partially filled, limited by six surfaces which are also divided, and which balance each other in their relations of position, dimension, and color. People sensed this vaguely when they divided a room space by means of furnishings and other objects. Even the walls were divided to some extent, if not by their own structure, at least by furnishings, pictures, etc. But all that was done in a more or less arbitrary way by means of objects more or less bizarre or arbitrarily chosen, so that it was a question of decoration rather than of relations and proportions.

Y: Agreed.

Z: The distribution of the space should not be effected primarily by objects brought into the room from outside: everything should contribute to the harmony. No art should be asked to do another's work. Industrial arts and painting should not replace architecture, and vice versa. They can only complete and deepen the architecture and the latter can only serve as their support. But things were not always thought of in that way: architects designed decorations and furnishings, and

116

painters practiced architecture in the realm of decoration. They tried to express constructive functions by means of decorations, forgetting that this was the architect's task. Thus, the flat surface was decoratively conceived of as having a limiting function; as a result, the motifs placed along the edges had the effect of enclosing the areas in question. Now the function of architecture is indeed to mark off limits, but the flat surface — at least the flat rectangle — has the plastic meaning of *extension*.

Y: Then architecture cannot itself express extension?

Z: Its constructive function is to *cover* the space; just the same, it expresses extension in its own fashion by its many partial constructions, and by its constructive organization of the whole.

Y: It is now clear to me that decorative painting, expressing itself in accordance with traditional formulas, can never sufficiently emphasize plastic extension.

Z: And painting for painting's sake can never be anything but decorative painting. Ultimately, both are one and the same thing; that is why it is perfectly logical, as both are purified, that the one transform itself into the other. Painting, once it is purified, operates with lines and colors alone.

The painting of the past, painting for painting's sake as well as decorative painting, has always more or less veiled the pure plastic elements by form and representation. By representation above all. The plastic ornament is, for instance, purer in certain old Moorish decorations than in the so-called rationalism of our modern epoch of naturalistic decoration and stylization.

Y: Are you applying the same ideas of pure plasticism to the contents of this room, the furnishings, the carpet, and everything commonly referred to as the applied arts?

Z: Of course I am. Only in this way is unity possible. Formerly, the elements which articulated space were not merely means but things in themselves, objects with individual existences, and separate from the whole. These elements scarcely had any essential relation to the form and color of the room. The room was decorated to suit the objects set in it, or these were chosen to suit the appearance of the room. Thus a certain harmony was achieved, but not an exact expression of balanced relations, because that requires the exact equivalence of the objects in their relations with each other. If the room is not bizarre in form, the furnishings and the ensemble must not be bizarre either.

Y: It's clear that the furnishings suit the rectangular form of the room to the degree that they themselves are rectangular.

Z: The form and color of a piece of furniture, its general aspect, should be in accord with the general aspect of the room; moreover, the relations of measurement, and the interrelations of color should also suit the room, for otherwise one cannot achieve pure equilibrium. Because of their form, which is usually rectangular, the canvases of naturalistic painters are indeed suitable to the rectangular

form of a typical room, provided that we do not look at what is painted inside the frame: It would be preferable to turn the faces of these pictures to the wall, so as to use them merely as elements in the articulations of the wall.

Y: So you think that the furnishings and all the objects in a room should be designed primarily to fit the room itself?

Z: If you want to achieve in the ordering of the whole an *exact* expression of perfectly balanced relationships, then everything has to be done in accordance with one and the same principle, in this case, the principle of Neo-Plasticism. Then the various branches of art cooperate automatically. Each skill has its own requirements, and needs its own servitors. For each skill requires unqualified devotion to it.

X: I'm afraid that if the method of Neo-Plasticism were followed through, the room might be somewhat lacking in intimacy.

Z: That would depend on the way the principles were applied — and on our personality. What one would call "intimate," would not necessarily be such for another. It even seems difficult to speak of "intimacy" in this connection, especially in view of the sentimental meaning the term often takes on in our language.[11]

We have read here how Mondrian designed his studio, where his friends could come and see him. He himself always presented a spick and span appearance in spite of his meagre wardrobe. He treated his guests with extreme courtesy and always made a point of entertaining them with music, as well as conversation. He was a great lover of music, and one of his most treasured possessions was a small portable gramophone painted in a pure "De Stijl" shade of red. He used to put on records for his guests — jazz records. In fact, he was particularly fond of jazz and regarded it as *the* music of the future. He kept up his tremendous interest in it until the very end of his days, as can be seen from the titles of some of his pictures, e. g. "Fox Trot" and "Broadway Boogie-Woogie." So it comes as no surprise to find that he loved dancing and enjoyed visiting Paris nightclubs. The architect Oud tells us about this side of his personality: "I have seen him dancing with some lively girl to the current rhythms of the day (especially jazz), which made such a strong appeal to him. Although he always followed the beat of the music, he seemed to interpolate a rhythm of his own. He was away in a dream, yet remained prim and precise and always kept exact time, although creating the impression of an artistic, indeed almost abstract, dancing figure. It could not have been much fun for the girl to drift across the dance floor in a kind of trance in the midst of all the normal pleasure-seeking throng. He himself was aware of this and later compensated the girl — most generously, considering his

slender means — for giving up her time to him. 'Perhaps she was expecting something else,' he would then say with that worldly wise, yet good-natured air of his."

Presumably he built up tensions in his dancing, just as he used lines and colors for the same purpose in his pictures. In dancing he transposed the horizontal and vertical lines of his paintings into movements set at right angles to one another. He slid across the dance floor like an automaton miraculously brought to life, with a fixed, ecstatic look on his face.

That was how Mondrian lived during his Neo-Plastic period. His works were strictly two-dimensional, without any hint or suggestion of a possible third dimension, and were painted in pure primary colors. In fact, they represent the extreme expression of what plastic art can achieve. I have found from my own experience that they convey a feeling of both strength and repose. One of Mondrian's Neo-Plastic pictures has been hanging in front of my desk for months. A painting like that can inspire a mood of introspection and meditation if one opens one's mind to it, and the longer one looks at it the more conscious does one become of undergoing some kind of spiritual experience.

I know there are many people who can make nothing of this type of art and dismiss it out of hand. "Anybody could paint like that!" they say. Our only answer to this must be to ask them to take a quiet look at Mondrian's pictures again and again, without any preconceived opinions. Fortunately, in my own experience I have discovered that people who could do this usually managed to find their way into Mondrian's world. I remember meeting a man on a quiet afternoon some years ago in the Mondrian Rooms at the Gemeentemuseum in The Hague. He had always spoken disparagingly of Mondrian's later works. But on the day in question I disturbed him in a mood of rapt contemplation. He asked me to go away and promised to come and see me when he was ready. Over an hour afterwards he walked into my office and said he believed that he had at last found the key to Mondrian's later works. He had indeed, and since then he has been an enthusiastic admirer of Mondrian's Neo-Plastic pictures.

Other people say that they understand the great importance of Neo-Plastic pictures for architecture and interior decoration, but that they surely could not be described as pictures in the true sense. That is about the most dangerous opinion anyone can possibly have about Mondrian's work. His painting is definitely autonomous and capable of standing on its own. Mondrian often found himself confronted with this attitude and fought vehemently against it. Of course, he advocated unification of all the different forms of artistic expression[12] and hoped that this would become a reality in the future. But it is not correct to say that he meant his pictures to be regarded as wall decorations. Of course, we are faced with the unalterable fact that a person may or may not be attracted by this

type of art, but it is rather difficult to understand why one should recognize dynamic abstractions as works of art, but not the static abstractions of Mondrian. All the material features that go to make up a picture, i. e. a pattern of lines and colors on a flat surface, are present. The fact that the content of the picture has been reduced to a minimum merely shows that the principle of repose has been carried emotionally and intellectually to its most extreme form. We should be glad to find one man at least amid all the hustle and bustle of modern society who is able to teach us the meaning of true repose. That is the experience of everyone whose life has been added to and enriched by Mondrian's art.

Another question arises here. Does this not, in fact, mark the end of a process of artistic development? Many years ago, in 1928, a heated argument on that very subject flared up at the Gymnasium Erasmianum in Rotterdam, the grammar school I was then attending. The subject under discussion was a café called "De Unie," a daring creation by the architect Oud that had sprung up immediately alongside the Renaissance-style school building. Our deputy headmaster, the great social historian Dr. R. Jacobsen, asked us that same question. His own answer was that many times in the history of western European painting a particular trend had appeared, and people thought that a *ne plus ultra* had been reached. But all these extremes were invariably followed by a new flowering of the arts, a new climax. Jacobsen was firmly convinced — and developments in the last few years have confirmed his prediction — that, just as in the case of the great Old Masters, Mondrian's art represented both an end and a new beginning.

In Holland Mondrian always had a small but loyal circle of friends and admirers who regularly came to have a look at his work and bought an occasional picture. One of the most important of these was Dr. H. P. Bremmer, who helped to found the Kröller-Müller Museum at Otterlo. When Mondrian was in Paris, an increasing number of art lovers from other nations swelled the circle of admirers, with the result that some of his Neo-Plastic works were to be seen as early as the mid-twenties in a number of collections outside Holland, for example, in Basel and at Yale University. Strangely, the French never really appreciated Mondrian's work. We do not find a single one of his pictures in the Paris galleries. Germans and people from Britain, Switzerland, and America came to see him and were attracted by his work at an early date. To give you a better idea of the type of person who showed an interest in him, I shall just mention a few of the relevant names. Carola Giedion-Welcker, the famous Swiss art critic, was one of the first to collect his work. Alfred Roth, the architect, and Max Bill, the sculptor, both from Zurich, were early members of Mondrian's circle of friends, from their student days. In 1922, Ida Bienert, one of the earliest and most knowledgeable collectors of modern art in Germany, bought the first of the series of eight pictures by Mondrian that were to be the pride of her collection. Two young students, Henry Clifford and James Johnson Sweeney,

both from America, came to see him at his studio in Paris. Later, when he was living in America, they became two of his most devoted friends and patrons. We must also mention the American collector Katherine S. Dreier, who brought together the extraordinary *Société Anonyme* collection that is now the pride of the Yale University Art Gallery, and the industrialist Burton Tremaine. The British artists Ben Nicholson and Barbara Hepworth were also great friends of his. And his work still aroused interest in his native Holland. In 1922 the Stedelijk Museum in Amsterdam held a retrospective exhibition to mark his fiftieth birthday.

In Paris he was one of the most distinguished members of the international group of artists who had joined together to form an association called *Cercle et Carré*. Other members were the Italian Luigi Russolo, the Russians Wassily Kandinsky, Gabo, and Lissitzky, the Pole Stajewski, and the Swiss Jean Arp. In that group Mondrian encountered works by the Constructivists for the first time. Strange to relate, that band of Russian artists had been working on virtually the same basic problems as the "Stijl" group around the time that it was being set up in Holland. This was really quite extraordinary, because in the early years the two groups did not know of each other's existence — the First World War had been the main reason no contact was established — and yet their theories and consequent results were almost identical. The Constructivists included Malevich, Lissitzky, Tatlin, Pevsner and Gabo. When Social Realism became compulsory in the Soviet Union and was recognized as the official form of art, and the Russian artists, except for Tatlin, left their native country, the two groups became amalgamated after 1925 with the *Cercle et Carré* in Paris and the *Circle* in London, although certain differences still persisted.

Mondrian's work also aroused great interest at the Bauhaus in Weimar. Thanks to Theo van Doesburg, who was then connected with that movement, Mondrian's essay "Neue Gestaltung" was published in the Bauhaus books in 1925. It was a translation of his pamphlet "Le néo-plasticisme," which had been published by Léonce Rosenberg, the art dealer, in Paris in 1920. It can therefore be assumed that Mondrian had won a fair amount of recognition, although this was confined to a relatively small circle of people. But the years in Paris must have been very good ones, judging by the pictures produced in that period. They reveal robust strength and at the same time a sense of quiet progress.

The diamond-shaped pictures can be regarded as the extreme and ultimate expression of his Neo-Plastic ideas. One of them is exhibited in the Kunsthaus in Zurich, another in the Museum of Modern Art in New York, and a third in the Gemeentemuseum in The Hague. The picture in the Kunsthaus in Zurich is completely in keeping with the other pictures from the Neo-Plastic period as far as composition and color distribution are concerned. It contains red, black, blue, and yellow. The picture in New York merely shows four black lines on a white ground, and the one in The Hague has four yellow lines

on a white ground. The lines in the New York picture give a sense of direction and movement — that is why it is called "Fox Trot A" — but the four lines in the picture in The Hague each cut a corner off the diamond and the static effect achieved in this way expresses perfect harmony. It is of interest here to quote the very precise instructions written by Mondrian on the reverse side of the picture in The Hague, as they are so typical of his orderly, meticulous nature: "When hanging the picture, please do not let it lean forward or backwards. It must be parallel to the wall, with the centre no lower than the eye-level of a man standing up and, if possible, with the bottom corner coming at eye-level — P. M. Please do not touch the picture, but take hold of it by the frame. The picture must be hung as a diamond, so that the letters TOP come uppermost. P. M."

This typical diamond shape occurs quite early in Mondrian's work. The first of these pictures dates from the year 1918 and has passed to the Gemeentemuseum in The Hague from the collection of A. P. van den Briel. There is also one from 1919 with light color planes and gray lines, preserved in the Kröller-Müller Museum. The latest is "Victory Boogie-Woogie," which belongs to Mondrian's friend Burton Tremaine of Meriden, Connecticut. As a point of interest, the picture in the Gemeentemuseum in The Hague is the only work before the New York period in which the lines have been done in color and not in black.

Mondrian's work changed gradually during his final years in Paris. Multiplication of the lines gave the pictures a certain dynamic force. The lines were still at right angles to one another, but they had been brought closer together and, for the first time in many years, they once again created a sensation of movement. This pattern of evolution led to a second division in Mondrian's work, which was just as important as the replacement of abstractionist tendencies by pure abstraction in the Neo-Plastic period. I shall be going into this in greater detail when discussing the pictures produced in London and New York.

10 In "An Essay in Dialogue Form" the characters are: Y an art-lover, X a naturalistic painter, and Z an abstract-realist painter.
11 "De Stijl," 1920, No. 6, pp. 54—56.
12 "By the unification of architecture, sculpture and painting, a new plastic reality will be created. Painting and sculpture will not manifest themselves as separate objects, or as 'mural art' which destroys architecture itself, or as 'applied art,' but being purely constructive will aid the creation of a surrounding not merely utilitarian or rational, but also pure and complete in its beauty." (From "Plastic Art and Pure Plastic Art," first published in the magazine "Circle," London 1937, and reprinted in the collection of essays of the same name, quoted above.)

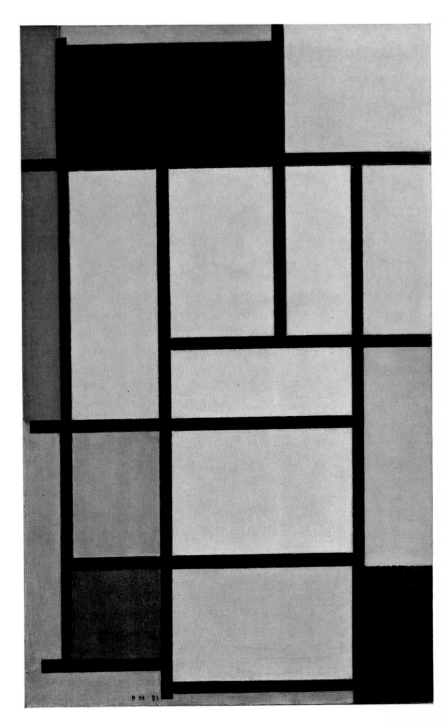

123 100 Composition with red, yellow and blue 1921

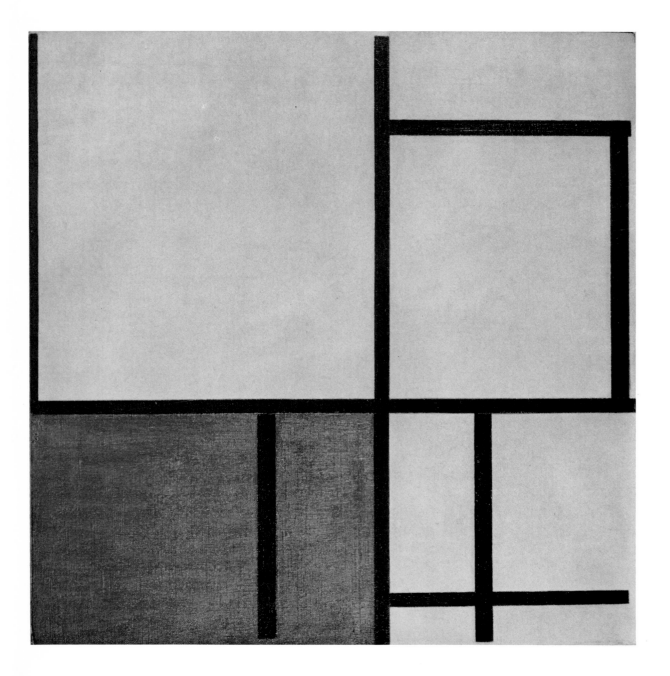

101 Composition with white, grey, yellow and blue 1922

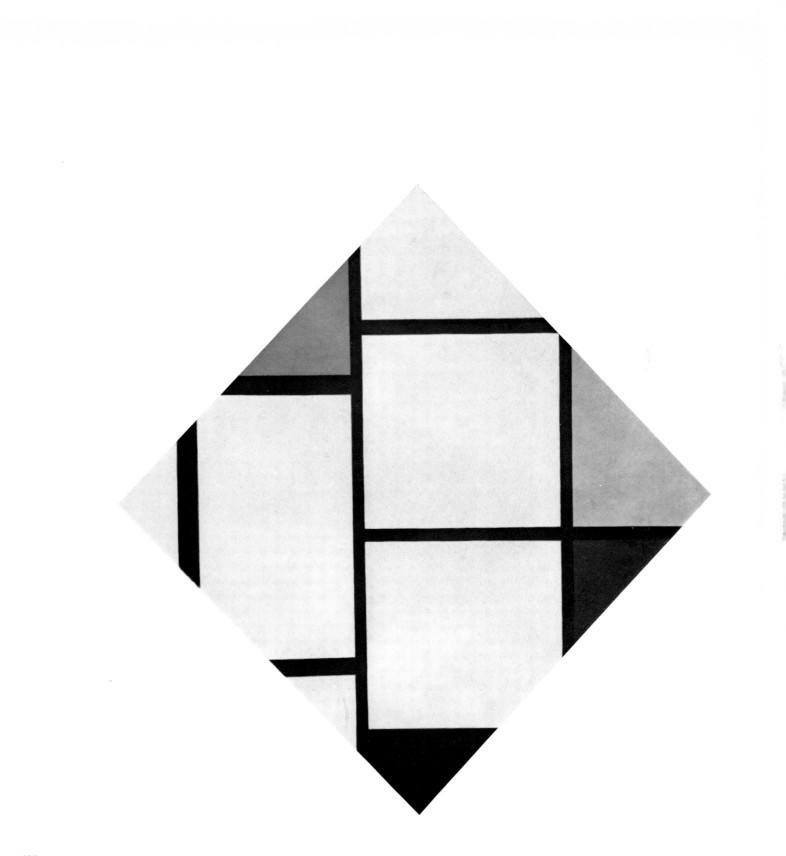

102 Composition in a square with red, yellow and blue 1926

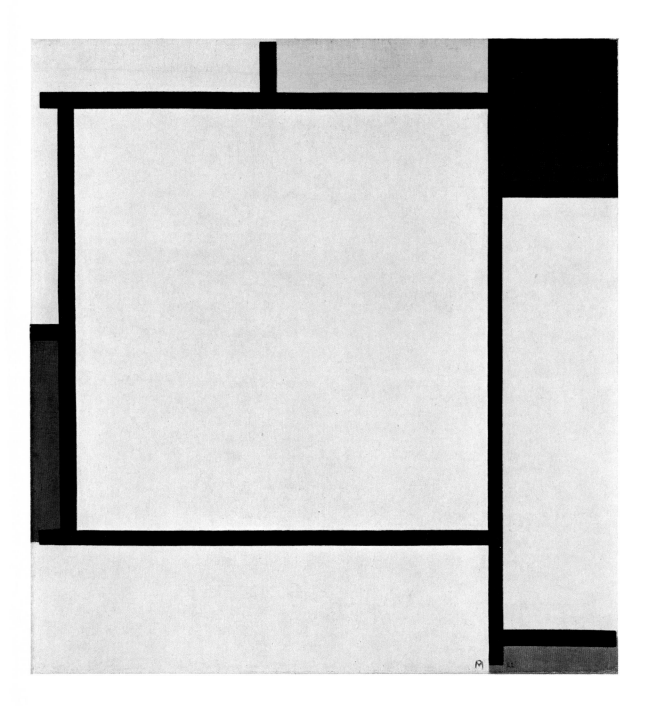

103 Composition 2 1922

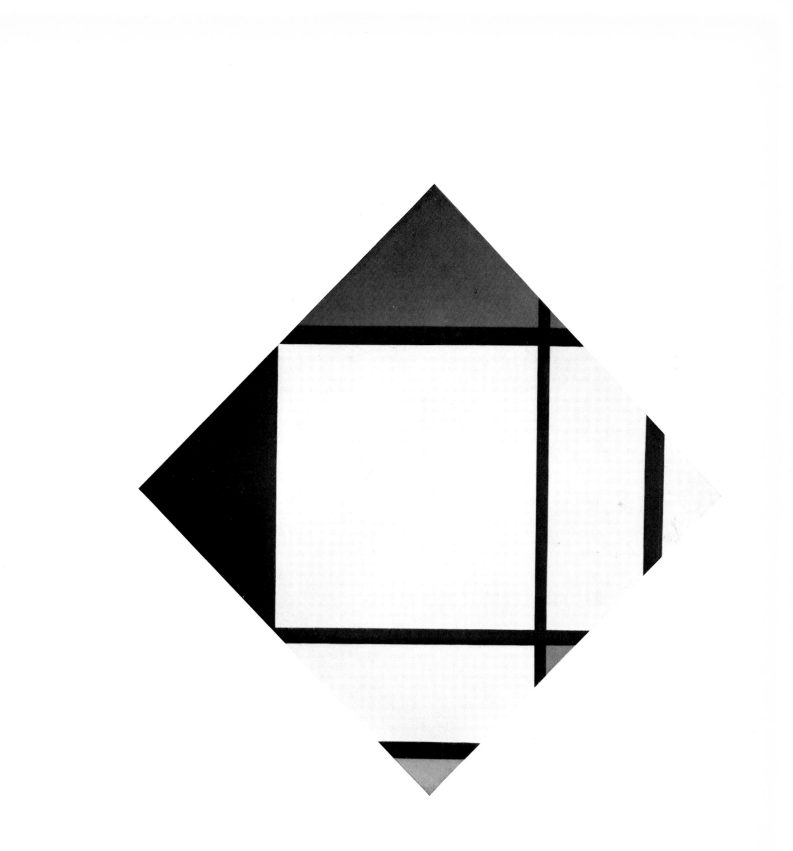

104 Composition (lozenge) 1925

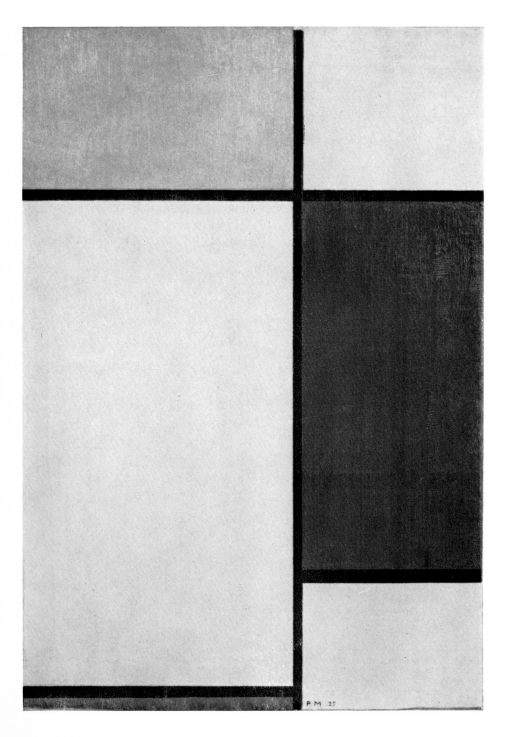

105 Composition with yellow,
red and blue 1927

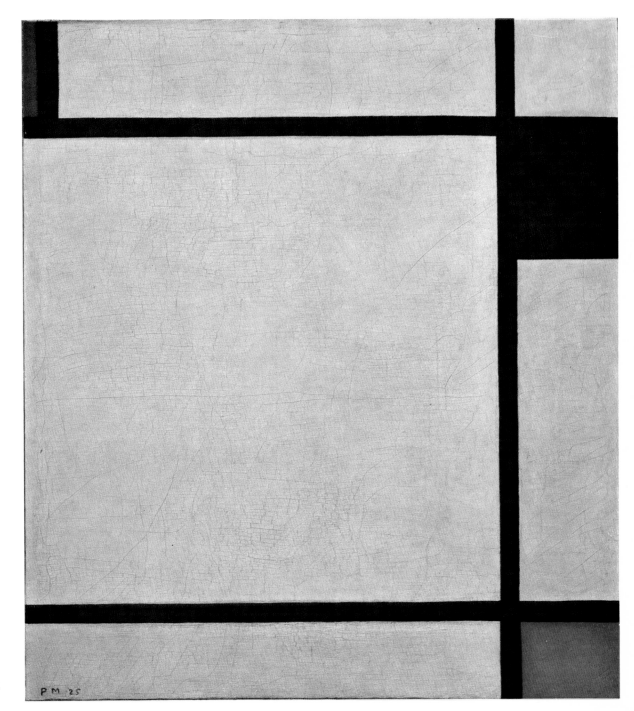

106 Tableau N VII.
Composition with
blue, yellow, black
and red 1925

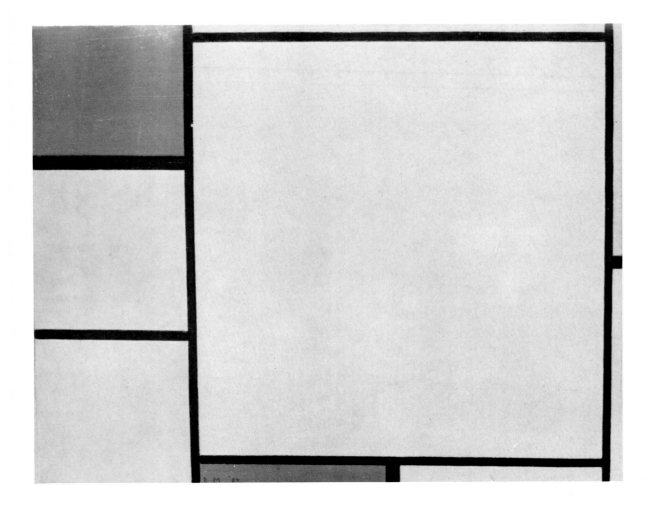

107 Composition with red, yellow and blue 1927

130

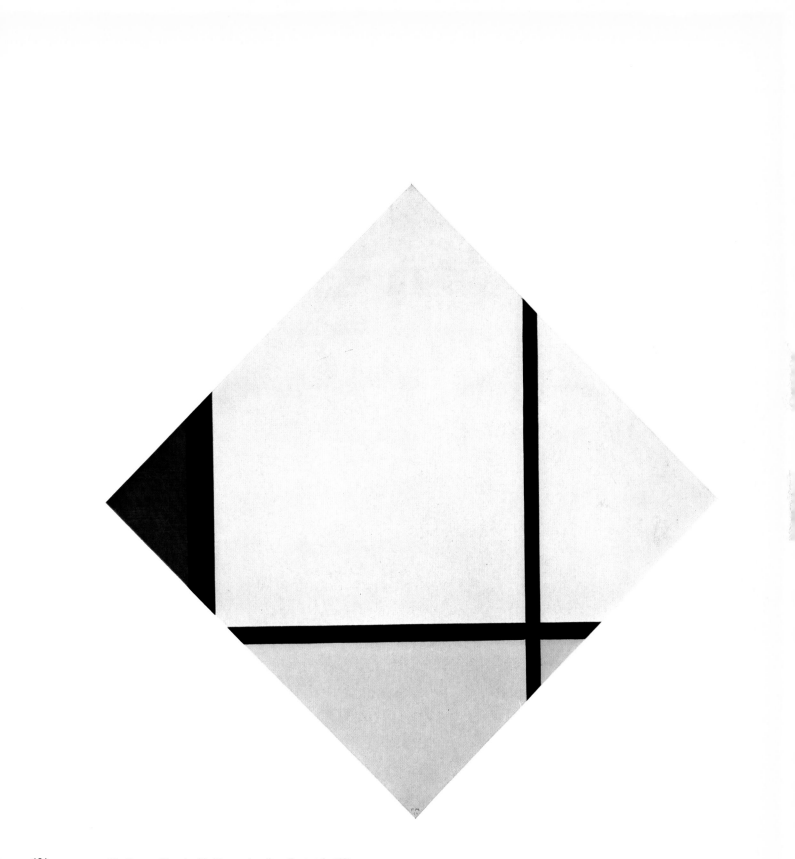

108 Composition I with blue and yellow (lozenge) 1925

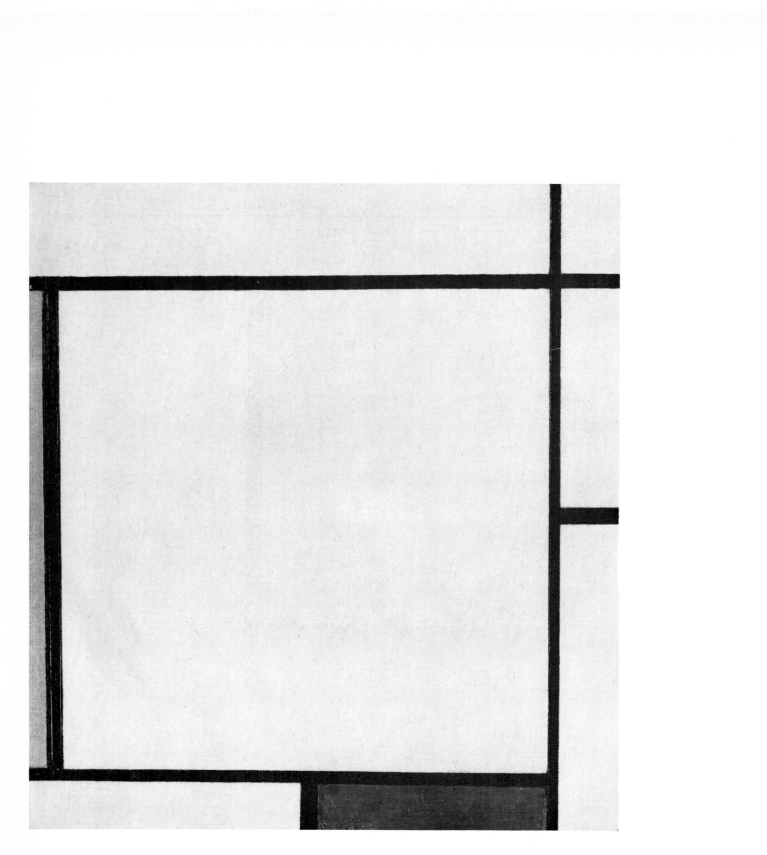

109 Composition 1927

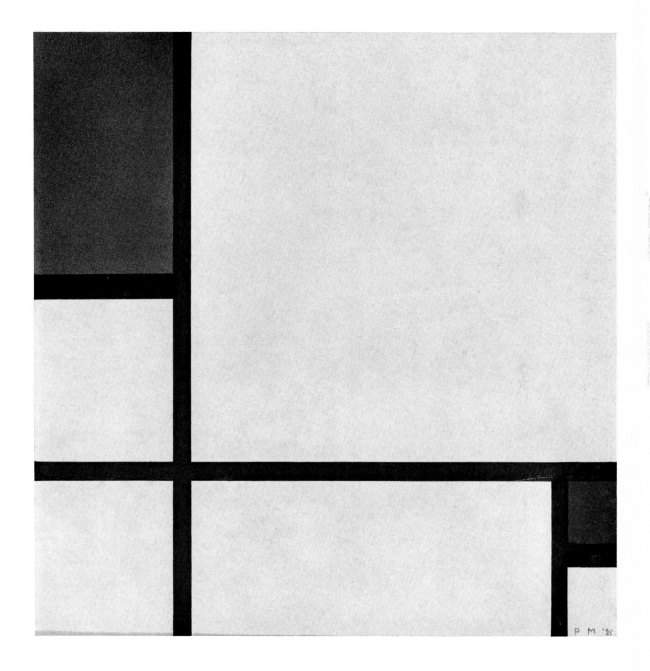

110 Composition 1929

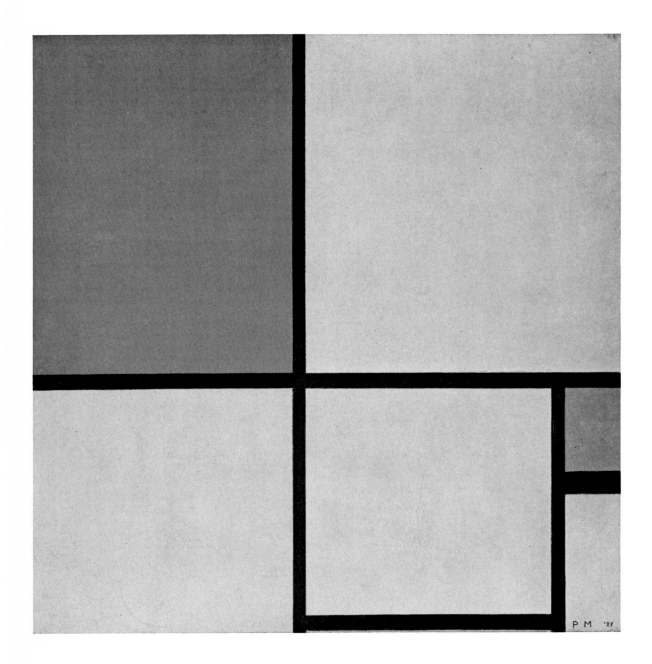

111 Composition with yellow and blue 1929

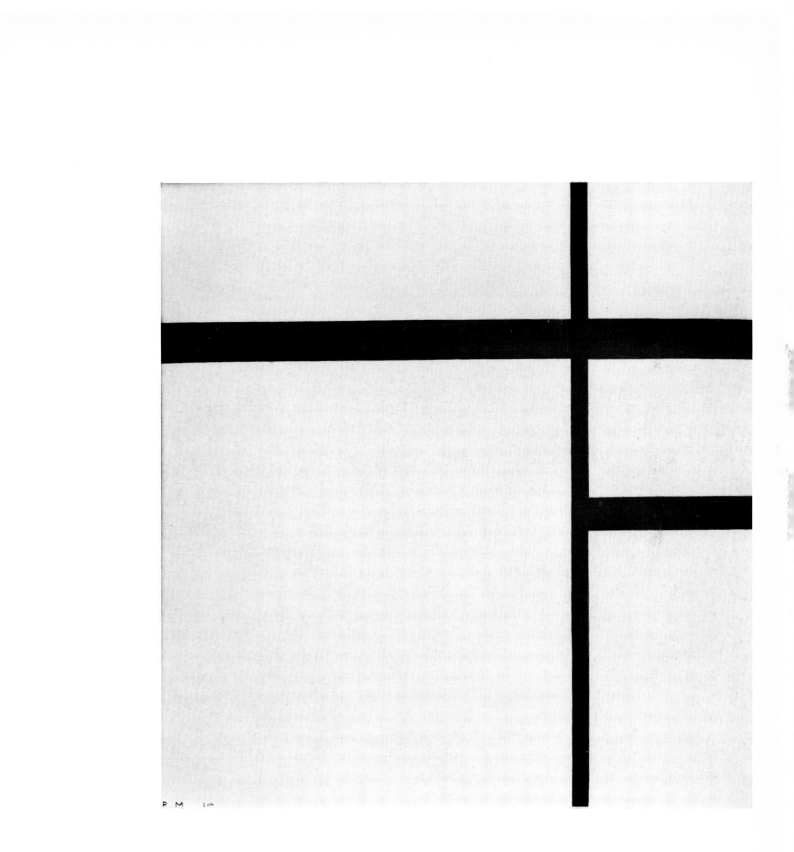

112 Composition II with black lines 1930

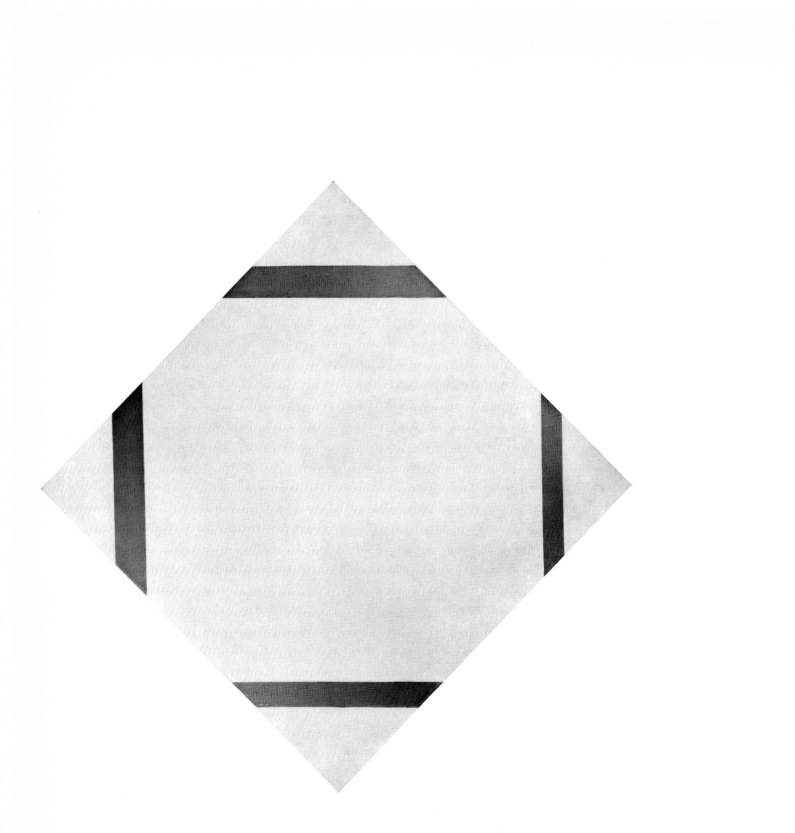

113 Composition with yellow lines (lozenge) 1933

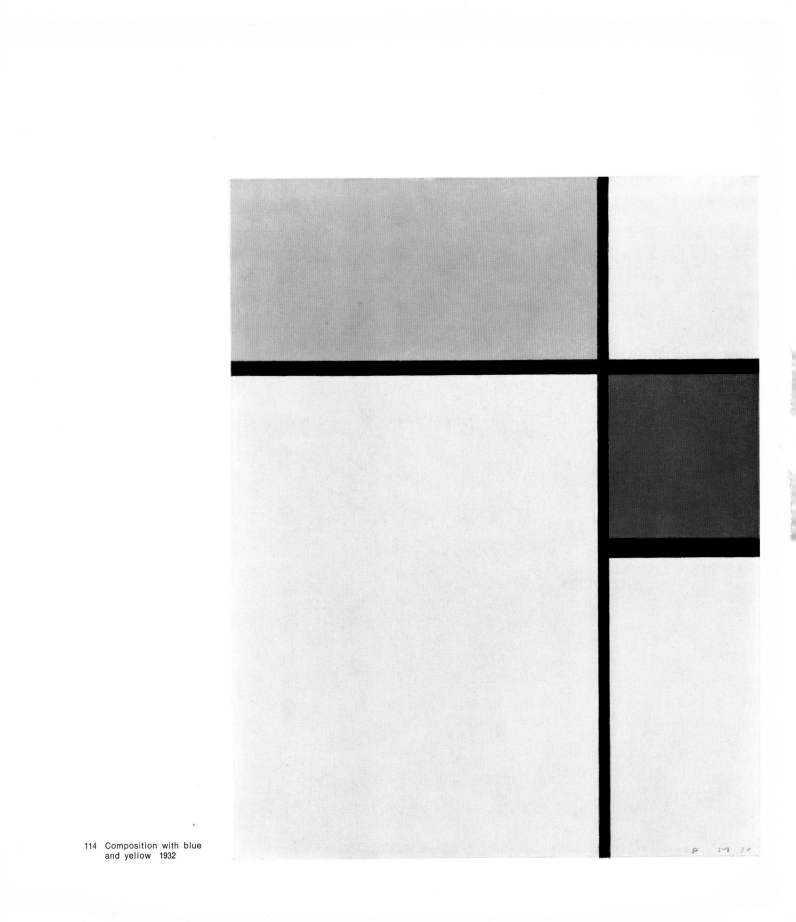

114 Composition with blue
and yellow 1932

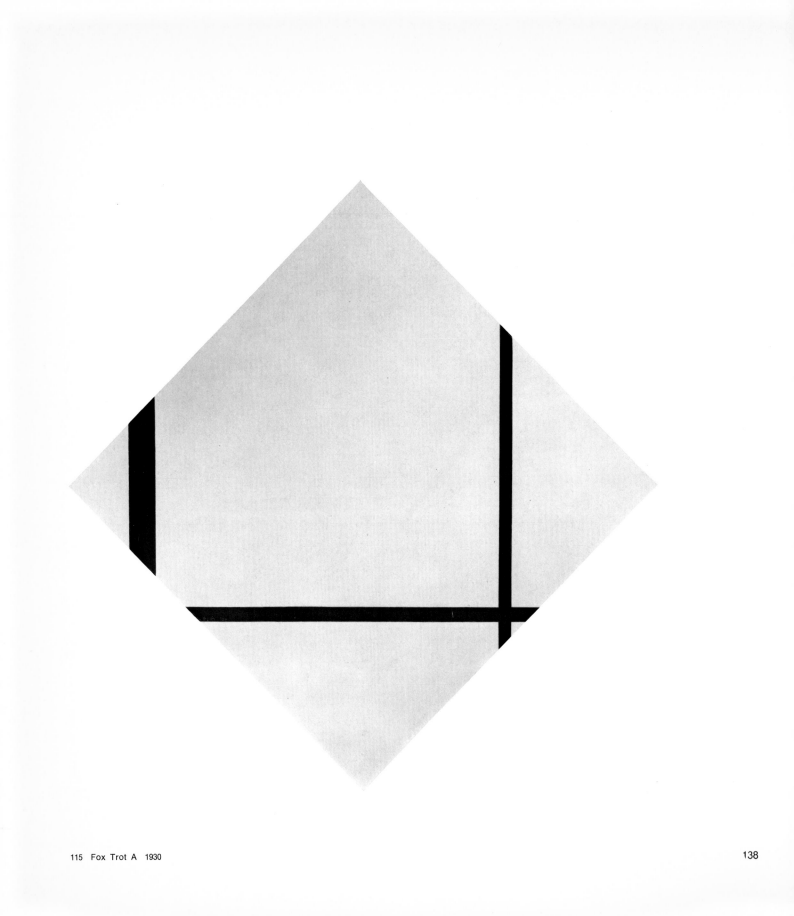

115 Fox Trot A 1930

London and New York
Farewell to pure abstraction

D¹ Mondrian among the artists in exile in New York 1942. From left to right: front row Matta, Zadkine, Tanguy, Ernst, Chagall, Léger; back row Breton, Mondrian, Masson, Ozenfant, Lipchitz, Tchelitchew, Seligmann, Eugene Berman.

page 142:

E¹ Mondrian's last studio in New York with "Victory Boogie-Woogie" on the easel 1943/44

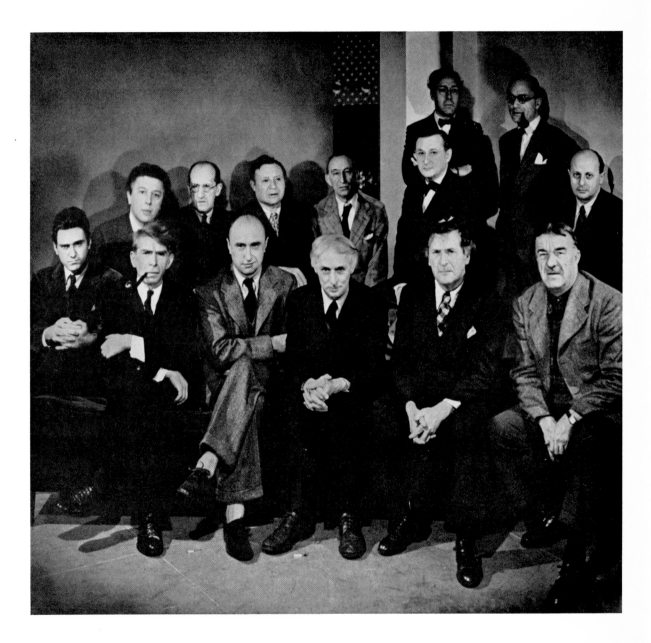

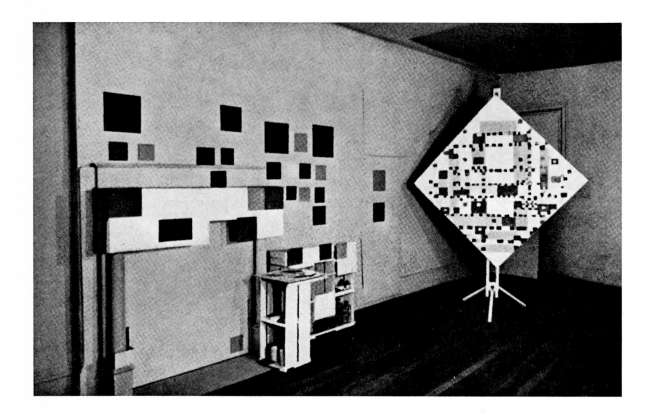

In 1938 Mondrian made up his mind to leave Paris, where he felt oppressed by the threat of the impending war. He traveled to London and found accommodation next door to his English friends the artists Ben Nicholson and Barbara Hepworth at 60 Park Hill Road, Hampstead. The British artists' group known as the *Circle* at once welcomed him into their midst, and he spent some happy and fruitful years in that environment. It is not very easy to establish precisely which works were actually produced at that time, as Mondrian often worked on a single picture for years. So quite a number of pictures must have been planned out in Paris and provisionally finished in London, but were probably only finally completed in New York.

The tendency evident in his final years in Paris was carried a stage further in London, and we can assume that it was here that he took the first steps along the road to free and dynamic plasticism, which he was to achieve in New York.

In the summer of 1940 the German Air Force began raids on London. When a nearby house was hit by a bomb, Mondrian decided to move once again, this time to New York. Many of the American friends he had acquired through the years — notably Harry Holtzman, who visited him in Paris for the first time in 1934 as a student of twenty-two — had been pleading with him to come to New York. He finally landed there on October 3rd, 1940.

First he lived at 353 East 56th Street, but he moved from there in October 1943 to 15 East 59th Street, which was to be his last home. He found himself surrounded almost immediately by a group of devoted friends. Apart from Harry Holtzman, whom we have mentioned, they included the Swiss painter Fritz Glarner, Charmion von Wiegand, who was German, and the American art critic and subsequently museum director James Johnson Sweeney. New York with all its bubbling vitality and animation appealed to him right from the start. He was impressed by all the many new things he saw around him, especially the skyscrapers, which he regarded as a kind of model or blueprint of the city of the future. The right-angled grid pattern of the streets must also have struck a familiar chord within him. And, as he emphatically declared on more than one occasion, he had a great admiration for the Americans, with their open nature and progressive outlook.

As I have already mentioned, a radical change was taking place in Mondrian's painting style — a change that has been deplored by the rigid theorists of Neo-Plasticism, because they saw in it a deviation from the principles he had previously followed. If we regard the development of painting and human character as a steady and consistent process, we shall undoubtedly feel that Mondrian's American pictures mark a clear departure from the principles that he himself had laid down. But in my opinion it is not necessary and indeed is quite wrong to be so stiff and uncompromising in this matter. We should feel nothing but admiration for the vigor and resilience of this man of sixty-eight who moved into a completely different environment and started looking at the world with new eyes.

That is surely far more commendable than rigid adherence to principles established some time previously. For that reason alone we should regard the paintings produced in America as the ultimate peak in the career of a great and determined man.

But what is different about these American pictures? It should, of course, be made clear at once that Mondrian remained true to the end of his days to the idea of horizontal and vertical lines intersecting at right angles. The process of evolution that had begun in his last years in Paris was continued and intensified here — i. e., the quest for a new dynamic quality. And there was something different as well. Instead of only black lines we find a pattern of both black and colored ones. The use of more than one color gives us the impression of lines running over one another, and as a result we find the third dimension reappearing in Mondrian's pictures. But the change goes even further than that. In the past, these black lines were always unbroken. Now they are cut up by the colored (yellow or red) lines into small cubes. In this way Mondrian has created a lively, tingling dynamic pattern, strongly reminiscent of the cube pictures of 1917. Underlying this we can detect a movement away from purely intellectual abstraction back to abstract treatment of subjects from the real world around us. Are we to regard this as a retrograde step? Not in my opinion. Mondrian must have believed he had found in the American way of life, as he saw it in the city of New York, the first glimmers of the society of the future that he had visualized, with all the different forms of art finally blended together in the harmonious life he had striven to establish here on earth. So he felt that it was vital for him to record his vision of New York and the external form of New York society in his pictures. A characteristic feature of those works is that their names nearly always conjure up the city of New York or jazz. He loved that type of music and regarded it as an integral part of the American way of life.

The most important works belonging to his American period are, I feel, the pictures produced in the years 1942–43 — "Broadway Boogie-Woogie" (now in the Museum of Modern Art in New York), which could certainly be regarded as the main work of that period; also "New York City" (in the Sidney Janis Collection, New York); and finally "Victory Boogie-Woogie" (Burton Tremaine Collection), that was standing unfinished on his easel when he died. We find in "New York City" to an even greater extent than in "Broadway Boogie-Woogie" that splendidly imposing quality always present in Mondrian's pictures.

In his book entitled *Mondrian* (Museum of Modern Art, New York, 1948), James Johnson Sweeney describes the line of development leading up to his last two pictures in the following manner: "Finally in his 'Broadway Boogie-Woogie,' 1943, and his unfinished 'Victory Boogie-Woogie,' we find him drawing all the strands of his research together. Here we have the restlessness and variety of minor form he had in his first post-cubist phase contrasted with a constant dominant rectangularity

throughout the composition. The primary colors of his mature years are mingled with softer, secondary squares reminiscent in tone of the golds and grays of his cubist work. And he has broken the aggressiveness of his lines, abandoning not only the black but even breaking the continuous character of the colored bands of his first New York work with a brilliant multicolored mosaic effect. The whole canvas now dances with variously sized rectangles of different colors. The eye is led from one group of color notes to another at varying speeds. At the same time, contrasted with this endless change in the minor motives, we have a constant repetition of the right angle theme, like a persistent bass chord sounding through a sprinkle of running arpeggios and grace notes from the treble." We cannot describe the full essence of Mondrian's final period more vividly than that.

Mondrian fell ill in January 1944. He lived like a recluse and permitted his friends to visit him only when he gave them a definite invitation to his home, so he lay there for two days without anyone to care for him. On January 25th he was taken to the Murray Hill Hospital, and he died there at five o'clock in the morning on February 1st. Standing unfinished on the easel was his "Victory Boogie-Woogie," that joyous, exultant picture expressing the confident hope that evil would finally be vanquished and a golden age would dawn. So ended the life of a man who never lost his faith in human nature and felt certain that good would one day overcome evil. He had traveled a long road from Amersfoort, the town of his birth, to the Cypress Hills Cemetery in Brooklyn. Hundreds of his friends, including many great artists of different nationalities who were living in New York at the time, accompanied him to his final resting-place on February 3rd, 1944.

He possessed a strong, indomitable spirit and tried to express certain principles throughout his life in words and pictures — principles that had grown out of the Dutch Calvinism practiced in his childhood home. Now the great hand and brain were at rest. But his pictures and his writings are the legacy left behind by this man who fought with such determination for the creation of a better world. In 1920 he dedicated his pamphlet on Neo-Plasticism "aux Hommes Futurs" — to the Men of the Future. It is our privilege to try and pass on his principles to these "Men of the Future," in the hope that they will one day see that better world dreamt of by Mondrian.

116 Rhythm with black lines 1935/42

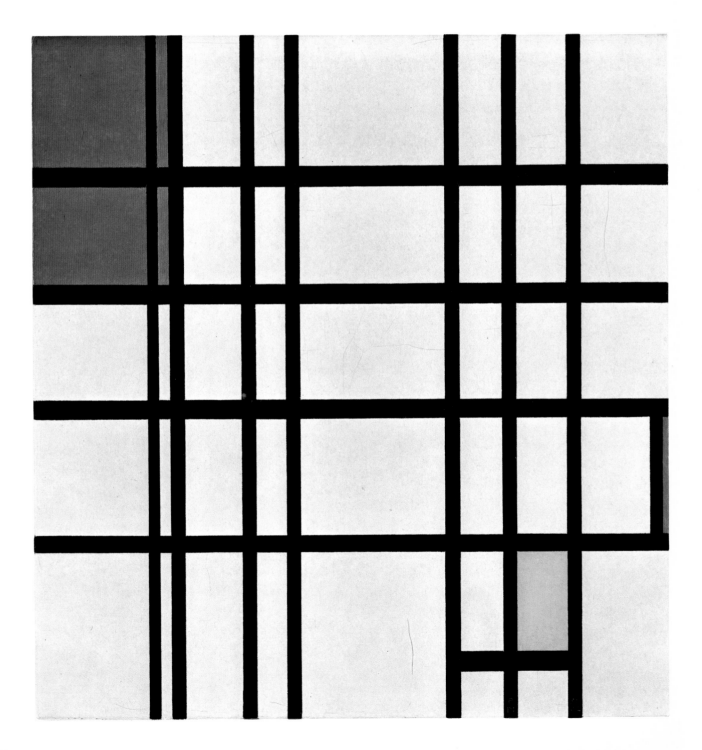

147

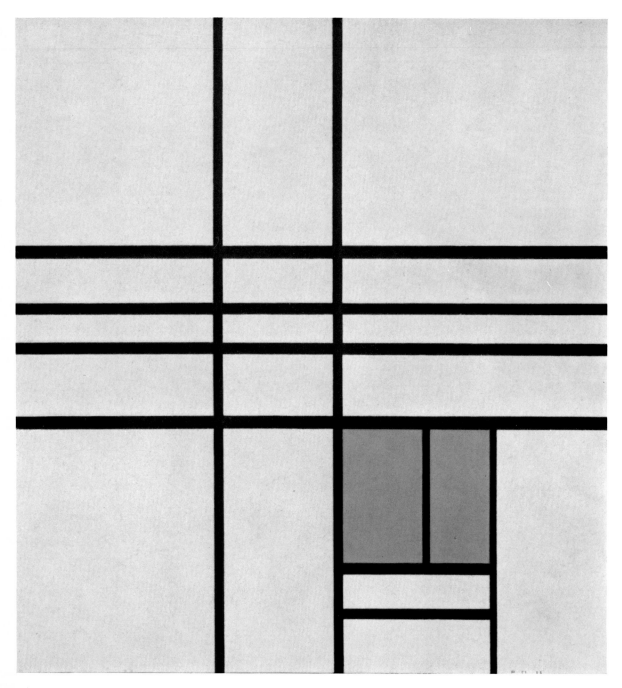

117 Composition with yellow spot 1936

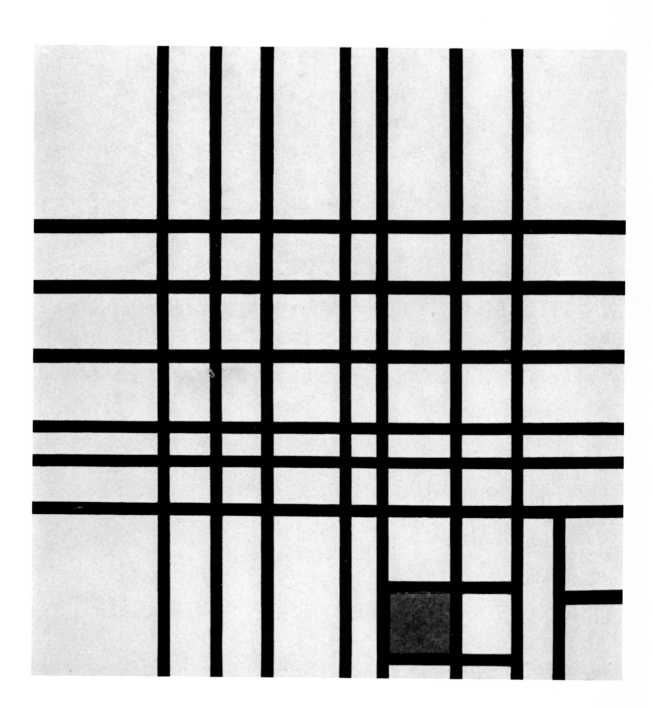

149 118 Composition Ii with blue 1936/42

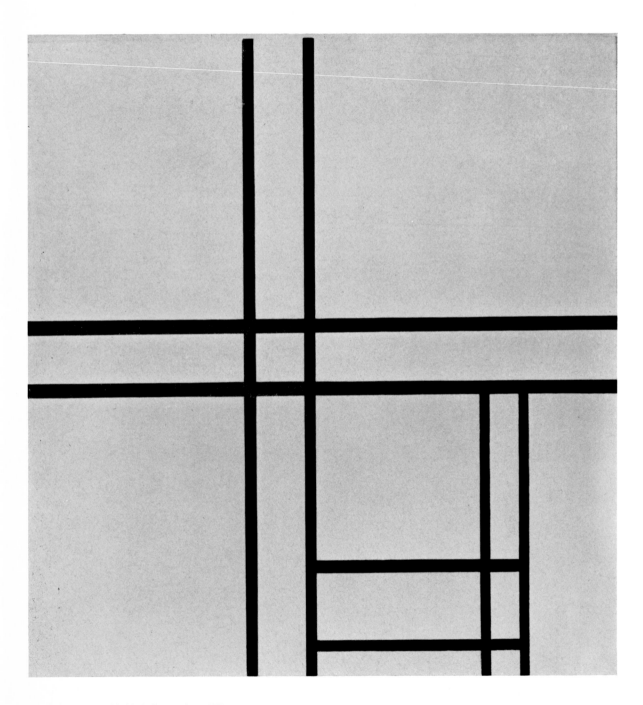

119 Composition with black lines about 1933

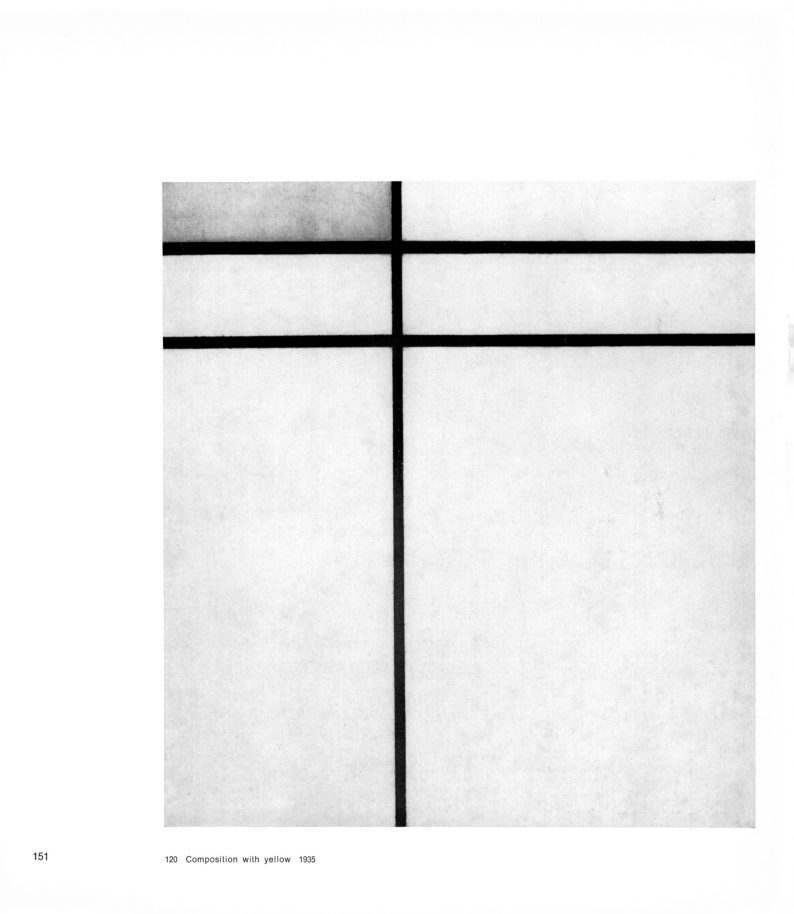

120 Composition with yellow 1935

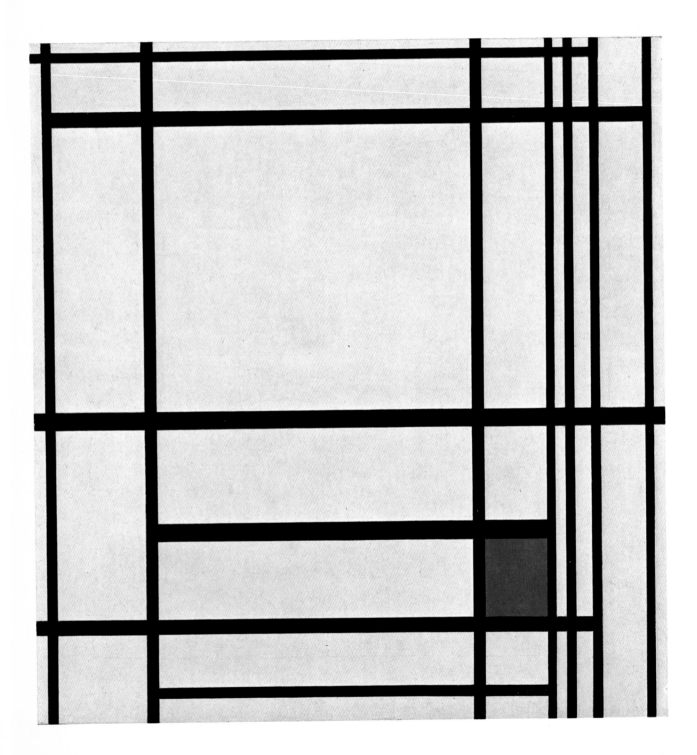

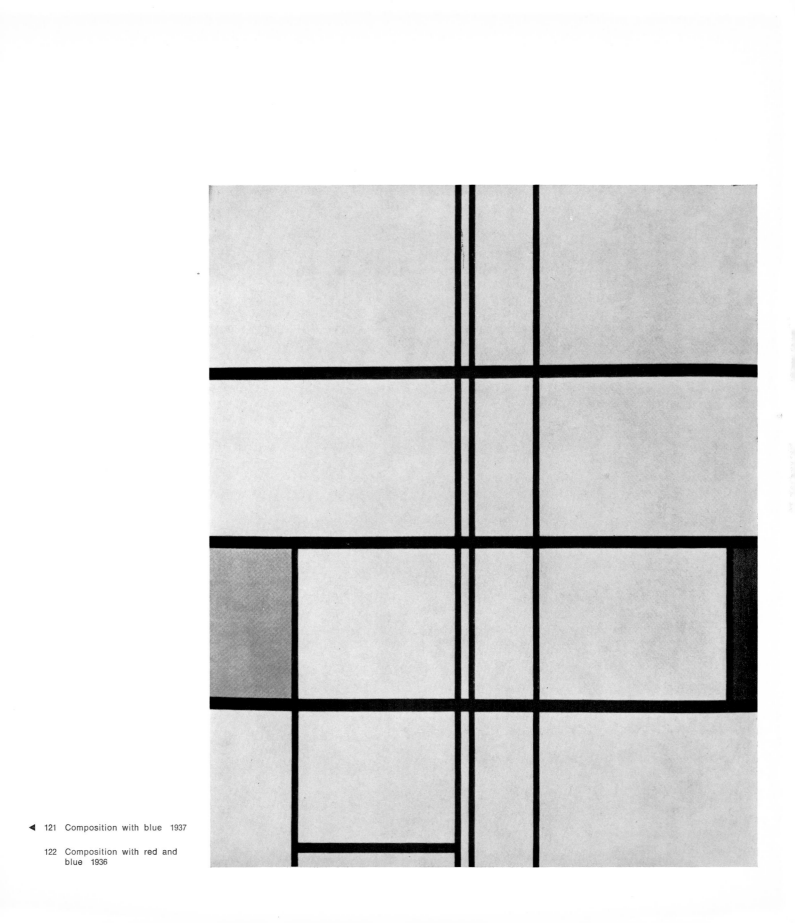

◄ 121 Composition with blue 1937

122 Composition with red and
blue 1936

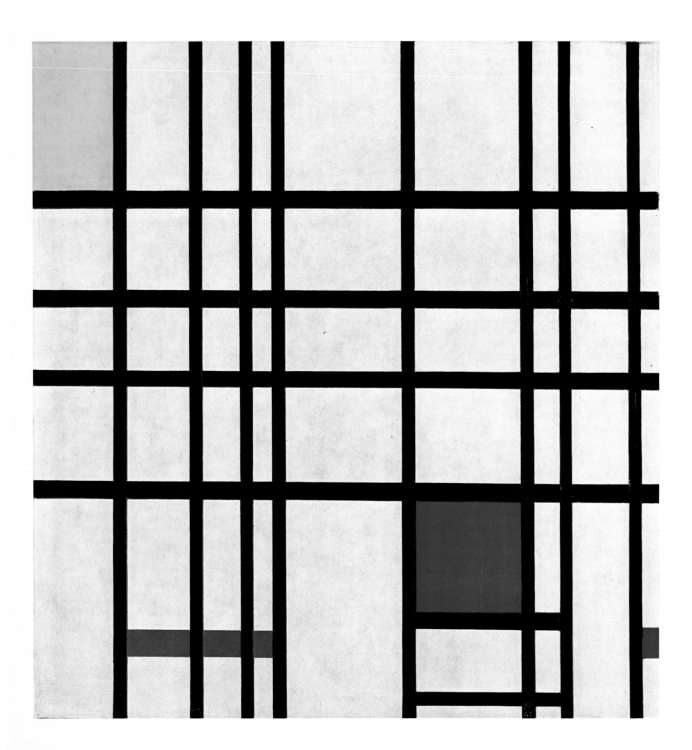

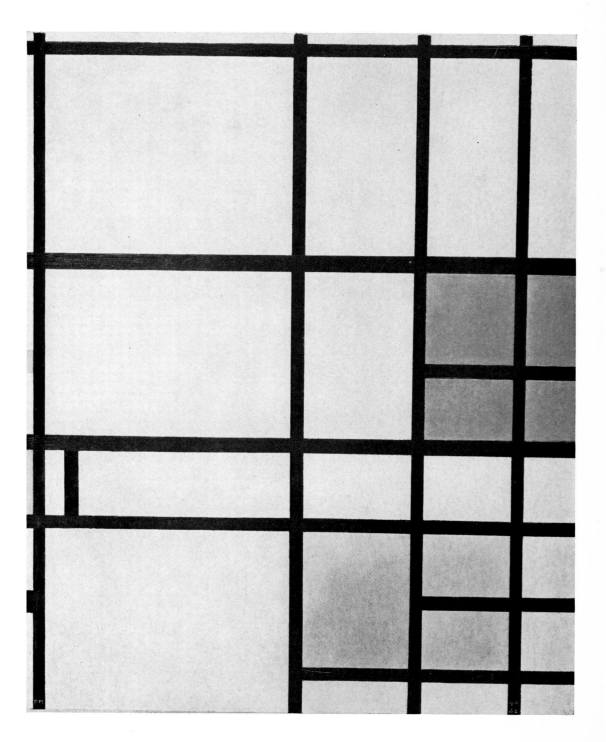

◄ 123 Composition with red,
 yellow and blue 1939/42

 124 Composition London
 1940/42

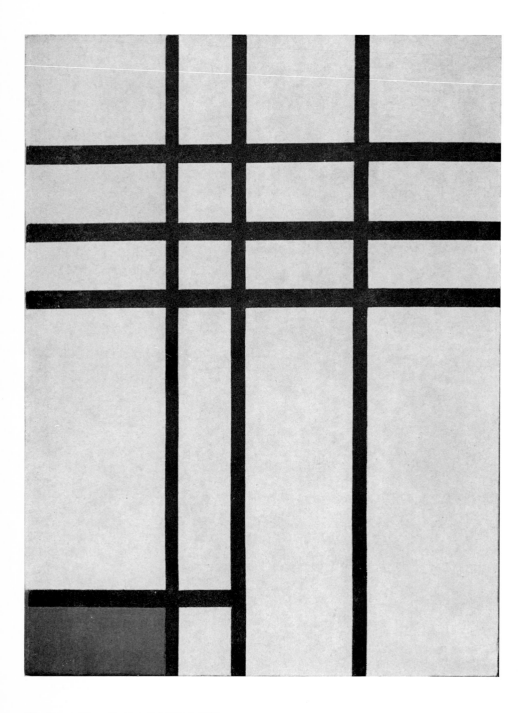

125 Composition with blue and yellow 1937

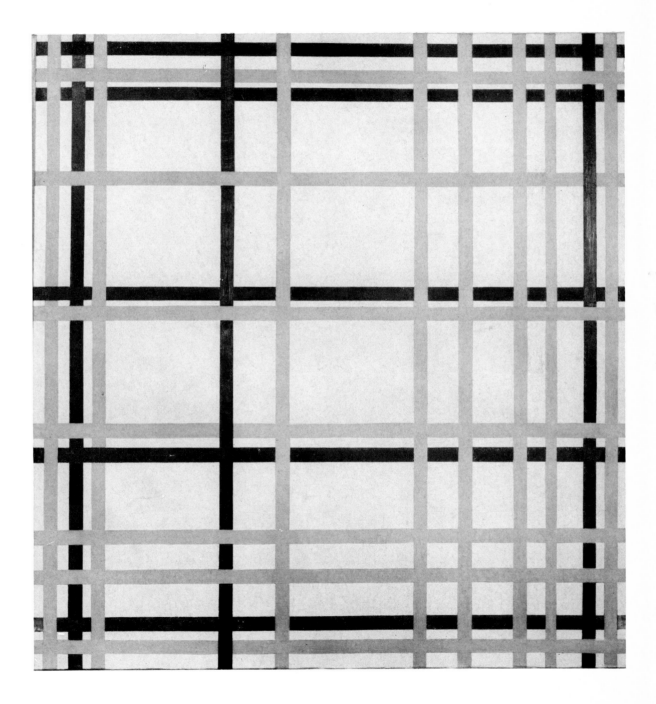

126 New York City I 1941/42

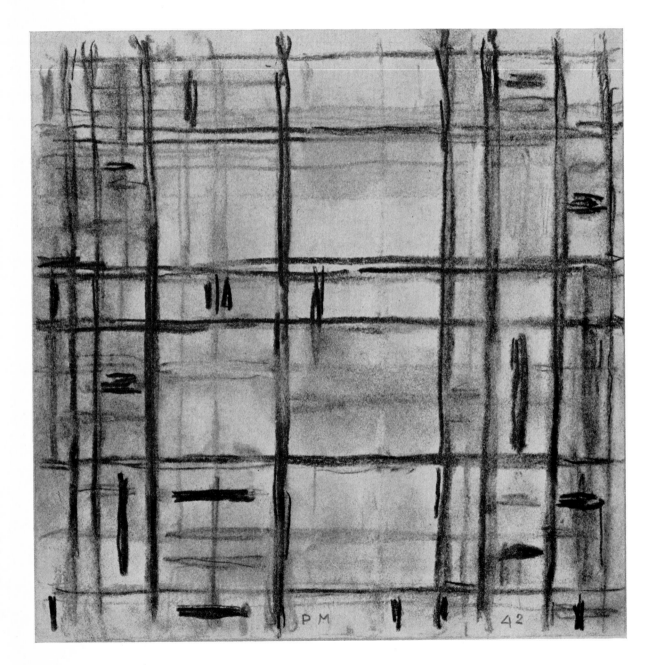

127 Charcoal sketch for Broadway Boogie-Woogie 1942

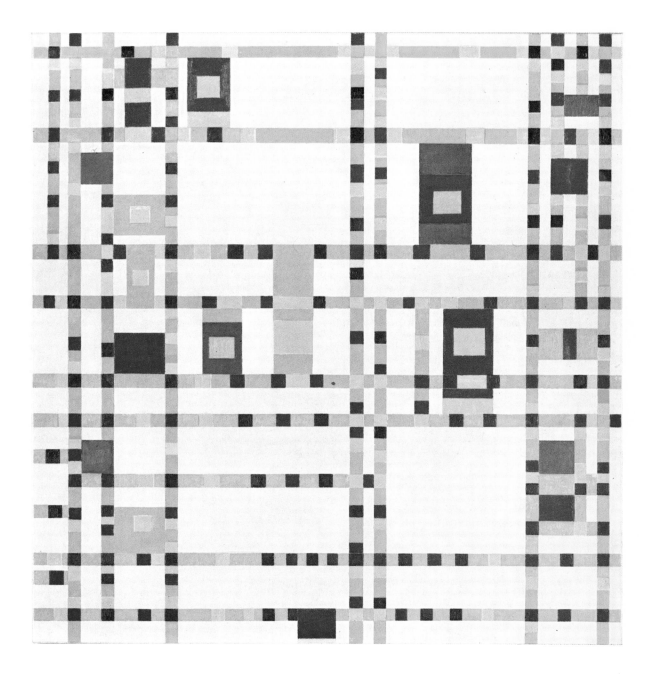

128 Broadway Boogie-Woogie 1942/43

129 Pencil sketch for Victory Boogie-Woogie 1943

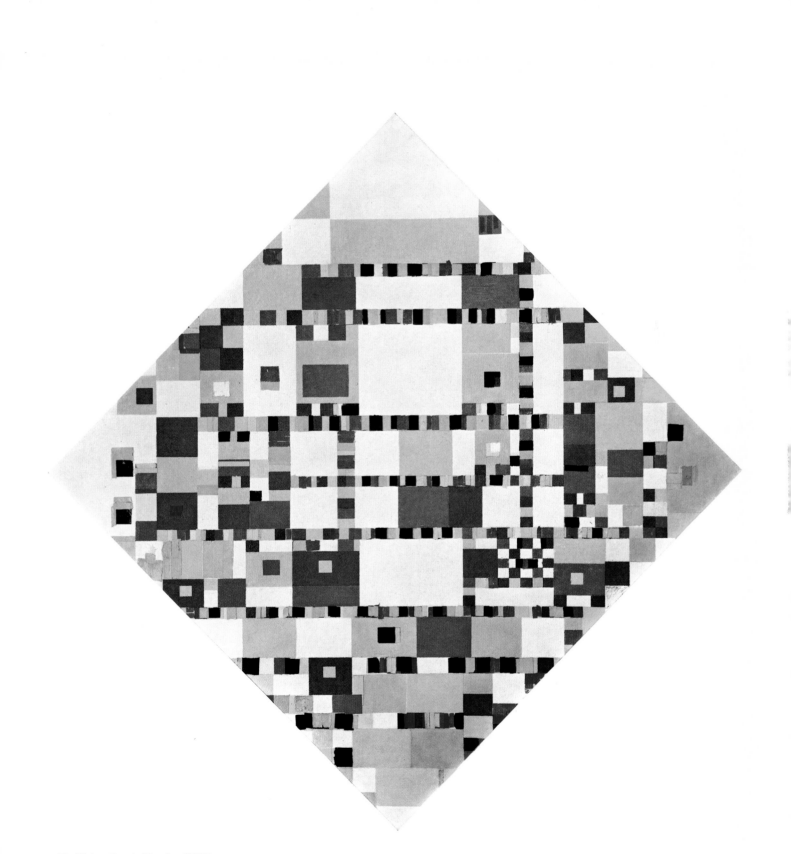

130 Victory Boogie-Woogie 1943/44

Biographical summary

1872	March 7th. Born at Amersfoort
1880	In April the whole family moves to Winterswijk First drawing lessons from his father and his uncle, the painter Frits Mondriaan (1853–1932). Studies art (1886–1889)
1889	Obtains diploma as teacher of drawing at primary schools. Teaches at a school in Winterswijk
1892	Obtains diploma as drawing teacher for secondary schools. Decides to become a painter. Meets art lecturer and artist J. Braet van Uberfeldt at Doetinchem. Becomes member of Utrecht Society "Kunstliefde" (Art-lovers)
1892—1894	Studies in Amsterdam State Academy under its Director, August Allebé
1894	Member of the Amsterdam artists' society "Arti et Amicitiae"
1894—1897	Evening classes at State Academy Earns a living by giving lessons in painting, doing portraits, copying paintings of Old Masters, and making botanical drawings. Meets Jan Sluyters and Simon Maris. First encounter with Theosophy
1897	First exhibition at "Arti et Amicitiae"
1898	Exhibition at Art Society, Guild of St. Luke
(About 1900)	Short stay in England
1901	Trip to Spain with Simon Maris
1900—1903	Works in neighborhood of Amsterdam and the Gein
1903	Visits Brabant in August
1904—1905	In January goes to Uden, paints in Nistelrode and Hilvarenbeek
1905	Returns to Amsterdam in February, paints portraits and gives painting lessons
1906	One of the 4 winners of the "Willink van Collen" Prize
1907	Works with the artist A. G. Hulshoff Poll, probably also at Oele. At the Four Year Exhibition in Amsterdam encounters Fauvist work by Kees van Dongen, Otto van Rees, Jan Sluyters, and others. Meets Jan Toorop

1908 His pictures attract attention from art critics at Spring Exhibition of Guild of St. Luke. In September visits Domburg in Zeeland for the first time

1909 In January joint exhibition at Stedelijk Museum, Amsterdam, with Jan Sluyters and C. Spoor. In Domburg with Spoor. In contact with Toorop and Jacoba van Heemskerck; last exhibition in October at "Arti et Amicitiae"

1910 Spring Exhibition at Guild of St. Luke, where a number of his Pointillist works are acclaimed by art critics as the most outstanding of their kind
At Domburg from August to October
In December resigns from "Arti et Amicitiae." Founding of "Circle of Modern Art" with Conrad Kickert, Jan Sluyters, and Jan Toorop

1911 Exhibits a picture "Soleil" at the Salon des Indépendants, Paris. Takes part in first exhibition of the art colony in Domburg
October—November first exhibition of the "Moderne Kunstkring;" works by Cézanne, Braque, Picasso, Derain, Le Fauconnier, Mondrian, and others
Moves to Paris at end of year, there meeting Kees van Dongen, Alma, and the composer Jacob van Domselaer

1912 Exhibitions: May: Sonderbund, Cologne; June: Salon des Indépendants, Paris; July— August: Domburg; October—December: Exhibition of "Moderne Kunstkring"

1913 Erster Deutscher Herbstsalon, Berlin

1914 His father's illness takes him to Arnhem. Outbreak of World War I prevents return to Paris. Exhibition at Walrecht's art dealer, The Hague

1914—1919 Stays in Amsterdam, Laren, and Blaricum. Summer in Domburg, meeting there Jan and Charley Toorop, Jacoba van Heemskerck, Marie Tak van Poortvliet and Mevrouw Elout-Drabbe. In Laren meets the philosopher Dr. M. H. J. Schoenmaekers. Meets S. Slijper in Blaricum. Is aided financially in 1916—17 by the art historian Dr. H. P. Bremmer

1914 In Domburg begins series of church façades and "pier and ocean" scenes, leading up to the "plus and minus" compositions. Mondrian begins to write his essays on art

1915 January—February: Exhibition of works by Alma, Le Fauconnier, and Mondrian in "Rotterdamse Kunstkring," and later in Groningen
June: After Sluyters and Gestel resign, Mondrian no longer exhibits in the "Moderne Kunstkring"
October: Exhibition of Schelfhout, Mondrian, Sluyters, Gestel, Le Fauconnier, and van Epen at Stedelijk Museum, Amsterdam
First meeting with Theo van Doesburg

1916 Meets Bart van der Leck; they both keep in touch with van Doesburg in Leiden, who in turn is in communication with the painter Vilmos Huszár, the architect J. J. P. Oud, and the poet Antony Kok. The idea of jointly publishing a periodical, already considered by van Doesburg in 1915, is now carried further
Takes part in Amsterdam exhibition of the "Hollandse Kunstenaarskring" in Amsterdam, sending in 4 compositions

1917 3 compositions in exhibition of "Hollandse Kunstenaarskring" in Amsterdam. A few early pictures at an exhibition entitled "De Bloemen" in Panorama-Gebouw, Amsterdam
October: Publication of first issue of the magazine "De Stijl." Mondrian writes the first of his articles, "New Forms in Painting"

1919 February—March: 5 compositions, among them diamond—shaped pictures in exhibition of "Hollandse Kunstenaarskring" at Stedelijk Museum, Amsterdam
Returns to Paris in July
Exhibition of 16 works at Walrecht's, an art dealer in The Hague

1920 Publication of Mondrian's pamphlet "Le néo-plasticisme," under imprint of Léonce Rosenberg
Takes part in exhibition in "Hollandse Kunstenaarskring" in Amsterdam and the "Haagse Kunstkring's" exhibition. In the "Modern Dutch Art" Exhibition at Brighton Art Gallery he submits 2 compositions

1922 Takes part in exhibition *Du Cubisme à une renaissance plastique* at Léonce Rosenberg's in Paris
In honor of 50th birthday, retrospective exhibition at Stedelijk Museum, Amsterdam, arranged by "Hollandse Kunstenaarskring"

1923 Submits work to exhibitions: "De Stijl" at Léonce Rosenberg's; "Works of Dutch masters in the last 25 years" at Rotterdamse Kunstkring; "Flowers and Still life." Buffa, art dealer, Amsterdam

1924 2 compositions at International Exhibition of the *Gesellschaft zur Förderung moderner Kunst* in Vienna

1925 Resigns from "De Stijl" owing to disagreement with van Doesburg
Exhibitions at Kühl and Kühn, Dresden, and at the Rotterdamse "Kring"
Publication in translation of "Le néo-plasticisme" under the title "Die neue Gestaltung" by the Bauhaus

1925—1929	Takes part in the following exhibitions: "De Onafhankelijken," Amsterdam, 1925, 1926, 1927; Potsdamer Kunstsommer, 1925; "L'Art d'Aujourd'hui," Paris, 1925, 1926; "De Bron," The Hague, 1925, 1926; "De Branding," Rotterdam, January 1926; Grosse Berliner Kunstausstellung, 1926; International Exhibition of the "Société Anonyme," Brooklyn, 1926; Salon des Tuileries, 1927; A. S. B., Stedelijk Museum, Amsterdam, 1928; Holländische Kunst, Dusseldorf, 1928; E. S. A. C., Stedelijk Museum, Amsterdam, 1929; Pulchri Studio, The Hague, 1929
1927	El Lissitzky builds up abstract collection in Landesmuseum in Hannover, which contains 2 of Mondrian's works Destroyed by the Nazis in 1936
1930	Member of the group "Cercle et Carré," founded by Joaquín Torres García and Michel Seuphor
1931	Member of group "Abstraction Création," founded by Georges Vantongerloo and Auguste Herbin
1930—1932	Takes part in exhibitions: "Cercle et Carré," 1930; "Från Kubism til Surimpressionism," Stockholm, 1930; "Art Vivant en Europe," Brussels, 1931; "De Onafhankelijken," Amsterdam, 1932
1934	Meets Ben Nicholson and Harry Holtzman
1937	London group "Circle" publishes his essay "Plastic Art and Pure Plastic Art"
1938	September 21st: Mondrian's departure for London
1940	October 3rd: Arrival in New York
1942	January—February: One-man show at Valentine Dudensing's in New York. Lectures for the "American Abstract Artists" in the Nierendorf Gallery in New York on "A New Realism." Takes part in exhibition "Artists in Exile" at the Pierre Matisse Gallery in New York
1943	Second one-man show in the Dudensing Gallery Jury-member for the First Spring Salon "Art of this Country" in New York
1944	February 1st: Dies of pneumonia in Murray Hill Hospital, New York
1944	February 3rd: Buried in Cypress Hills Cemetery in Brooklyn

Were are indebted to Professor Robert Welsh and C. Blok for the information contained in this biographical summary.

Bibliography

Abbreviations:

Sweeney	J. J. Sweeney, Piet Mondrian. Museum of Modern Art bulletin XII, 4, 1945. New edition 1948, containing also "An Interview with Mondrian".
Morisani	O. Morisani, L'astrattismo di Piet Mondrian; con appendice di scritti dell'artista. Venice 1956.
Seuphor	M. Seuphor, Piet Mondrian; life and work; 1st edition, New York/Amsterdam 1956. German edition, Cologne 1956. Seuphor . . . or S . . . — List of all known Works (pp. 409—432), No . . . c. c . . . — Classified Catalogue (pp. 357—395), No . . . (Seuphor 181, c. c. 75 is No. 181 in the List of Works and No. 75 in the Classified Catalogue). N. B. In later impressions the List of Works is numbered differently.
Lewis	D. Lewis, Mondrian. London 1957; German edition, Berlin 1960.
Denise René	Mondrian; présenté par Vasarely; introduction par Michel Seuphor. Paris 1957. Album of pictures published by the Denise René Gallery.
Hunter	S. Hunter, Mondrian. London 1958.
Seuphor 1958	M. Seuphor, Mondriaan, composities. The Hague 1958. Kleine kunst-encyclopaedie 15.
Terpstra	A. B. Terpstra, Moderne kunst in Nederland 1900—1914. Utrecht 1958/59.
Jaffé 1959	H. L. C. Jaffé, Inleiding tot de kunst van Mondriaan. Assen/Amsterdam 1959.
Wijsenbeek-Oud	L. J. F. Wijsenbeek and J. J. P. Oud, Mondriaan. Zeist 1962.
Ragghianti	C. L. Ragghianti, Mondrian e l'arte del XX secolo. Milan 1962.
Menna	F. Menna, Mondrian; cultura e poesia. Rome 1962.

Literature by Mondrian

De nieuwe beelding in de schilderkunst. De Stijl I, 1917/18, 1, pp. 2—6, 2, pp. 13—18, 3, pp. 29—31, 4, pp. 41—45, 5, pp. 49—54, 7, pp. 73—77, 8, pp. 88—91, 9, pp. 102—108, 10, pp. 121—124, 11, pp. 125—134, 12, pp. 140—147.

Die Neue Plastik in der Malerei. M. Seuphor, Knaurs Lexikon abstrakter Malerei, Munich 1957, pp. 110—113 (translation of the first edition).

Het bepaalde en het onbepaalde (supplement to: De nieuwe beelding in de schilderkunst). De Stijl II, 2, 1918,. pp. 14—19.

Dialoog over de nieuwe beelding (zanger en schilder). De Stijl II, 1919, 4, pp. 37—39, 5, pp. 49—53.

Natuurlijke en abstracte realiteit. De Stijl II, 1919, 8, pp. 85—89, 9, pp. 97—99, 10, pp. 109—113, 11, pp. 121—125, 12, pp. 133—137; III 1919/20, 2, pp. 15—19, 3, pp. 27—31, 5, pp. 41—44, 6, pp. 54—56, 8, pp. 65—69, 9, pp. 73—76, 10, pp. 81—84.

Reprinted as appendix to the monograph by M. Seuphor, Piet Mondrian, 1956: Natural Reality and Abstract Reality; an Essay in Dialogue Form. Seuphor, pp. 301—352.

Le néo-plasticisme; principe général de l'équivalence plastique. Paris, Ed. de l'Effort Moderne (Léonce Rosenberg), 1920. Reprinted in Catalogue of Mondrian Exhibition, The Hague, Gemeentemuseum 1955. Review with quotations in De Stijl IV, 1921, 2, pp. 18—23.

Die neue Gestaltung. Munich 1925. Bauhausbuch 5.

Neo-plasticism. Catalogue of Mondrian Exhibition, London, Whitechapel Art Gallery 1955, pp. 13—45.

Il Neoplasticismo. Morisani, pp. 51—71.

De groote boulevards. De Nieuwe Amsterdammer 272, 27 March 1920, pp. 4—5; 274, 3 April 1920, p. 5.

De "bruiteurs futuristes italiens" en "het nieuwe" in de muziek. De Stijl IV, 1921, 8, pp. 114—118, 9, pp. 130—136.

La manifestation du néo-plasticisme dans la musique et les bruiteurs italiens. La vie des lettres et des arts, Paris 1922.

Die Neue Gestaltung in der Musik und die futuristischen italienischen Bruitisten; French translation by Max Burcharts. De Stijl VI, 1923, 1, pp. 1—9, 2, pp. 19—25. Reprinted in Die Neue Gestaltung, 1925, pp. 29—42.

La nuova rappresentazione nella musica ed i rumoristi italiani. Morisani, pp. 85—95.

Het Neo-plasticisme (de Nieuwe Beelding) en zijn (hare) realiseering in de muziek. De Stijl V, 1922, 1, pp. 1—7, 2, pp. 17—23.

Le néo-plasticisme, sa réalisation dans la musique et au théâtre futur. La vie des lettres et des arts 1922.

Die Neue Gestaltung, ihre Verwirklichung in der Musik und im zukünftigen Theater. Die Neue Gestaltung, 1925, pp. 42—53.

Il neoplasticismo, la sua realizzazione nella musica e nel teatro futuro. Morisani, pp. 96—106.

De realiseering van het Néo-plasticisme in verre toekomst en in de huidige architectuur. De Stijl V, 1922, 3, pp. 41—47, 5, pp. 65—71.

Die Verwirklichung der Neuen Gestaltung in weiter Zukunft und in der heutigen Architektur. Die Neue Gestaltung, 1925, pp. 54—64.

La realizzazione della nuova rappresentazione nel lontano futuro e nell'architettura di oggi. Morisani, pp. 72—82.

Het Neo-plasticisme. Merz 6 (Imitatoren), 1923.

Moet de schilderkunst minderwaardig zijn aan de bouwkunst? De Stijl VI, 5, 1923, pp. 62—64.

Muß die Malerei der Architektur gegenüber als minderwertig gelten? Die Neue Gestaltung, 1925, pp. 65—66.

Deve la pittura essere considerata inferiore all' architettura? Morisani, pp. 83—84.

Les arts et la beauté de notre ambiance tangible. Manomètre, Lyons 1924.

Geen axioma maar beeldend principe. De Stijl VI, 1924, 6/7, pp. 83—85.

De huik naar den wind. De Stijl VI, 1924, 6/7, pp. 86—88.

L'architecture future néoplasticienne. L'architecture vivante III, 9, 1925, pp. 11—13.

L'expression plastique nouvelle dans la peinture. Cahiers d'art 7, 1926, pp. 181—183. Reprinted Cahiers d'art 22, 1947, pp. 111—115.

L'espressione plastica nuova nella pittura. Morisani, pp. 107—110.

Principes généraux du Néo-plasticisme. 1926. Reproduced as a manuscript in Art d'aujourd'hui 5, 1949, pp. 1—2.

General principles of Neo-plasticism. Seuphor, pp. 166—168.

Neo-plasticisme; de woning — de straat — de stad. Internationale revue i 10, I, 1, 1927, pp. 12—18. Reprinted in i 10, The Hague 1963, pp. 29—35.

Le home — la rue — la cité. Vouloir 25, Lille 1927. Extracts in Art d'aujourd'hui 5, 1949, p. 5, and in J. Cassou, Panorama des arts plastiques contemporains, Paris 1960, pp. 515—517.

Home-street-city. Transformation I, New York 1950.

Casa-strada-città. Morisani, pp. 111—119.

Diskussion über Ernst Kállai's Artikel "Malerei und Photographie". Internationale revue i 10, I, 6, 1927, p. 235.

De jazz en de Neo-plastiek. Internationale revue i 10, I, 12, 1927, pp. 421—427. Reprinted in i 10, The Hague 1963, pp. 155—161.

Ne pas s'occuper de la forme... Cercle et Carré 1, Paris 1930.

L'art réaliste et l'art superréaliste; la morphoplastique et la néoplastique. Cercle et Carré 2, Paris 1930. Reprinted in P. Citroen, Palet, Amsterdam 1931, pp. 76—82.

L'arte realistica e l'arte superrealistica. Morisani, pp. 120—127.

De l'art abstrait; réponse de Piet Mondrian. Cahiers d'art VI, 1, 1931, pp. 41—43.

English translation in Art Students' League Quarterly 1941.

Risposta ai Cahiers d'art. Morisani, pp. 128—133.

Art and life; translated by Til Brugman. 1931. First published in H. L. C. Jaffé, De Stijl, Amsterdam 1956, pp. 209—254.

Notities bij het overlijden van Theo van Doesburg. De Stijl, dernier numéro, 1932, pp. 48—49.

La néo-plastique. Abstraction, Création, Art non figuratif 1, 1932, p. 25. Followed by short notes in No. 2, 1933, p. 31, and No. 3, 1934, p. 32.

La neoplastica. Morisani, pp. 134—135.

La vraie valeur des oppositions. 1934. First published in Cahiers d'art 22, 1947, pp. 105—108.

The true value of oppositions. H. L. C. Jaffé, De Stijl, Amsterdam 1956, pp. 255—258.

Reply to an enquiry. Cahiers d'art 10, 1935, p. 31.

Plastic art and pure plastic art. London, Circle 1937. Reprinted in Plastic art and pure plastic art, New York 1945.

Arte plastica e pura arte plastica. Morisani, pp. 137—152.

Three notes. Transition 26, 1937, pp. 118—119.

Kunst zonder onderwerp. Catalogue for Exhibition of Abstract Art, Amsterdam, Stedelijk Museum 1938, pp. 6—8. Reprinted in Kroniek van hedendaagsche kunst en kultuur III, 6, 1938, pp. 166—168.

Kunst ohne Objekte. Exhibition Catalogue of Kunsthaus, Zurich 1955, pp. 11—13.

Liberation from oppression in art and life. 1941. First published in Plastic art and pure plastic art, New York 1945.

Liberazione dall'oppressione nell'arte e nella vita. Morisani, pp. 156—169.

Toward the true vision of reality. New York, Valentine Gallery 1942. Reprinted in Plastic art and pure plastic art, New York 1945.

Verso la vera visione della realtà. Morisani, pp. 170—175.

Lebenserinnerungen und Gedanken zur Neuen Gestaltung. Du 16, 1956, pp. 16—22. Reprinted in Das Kunstwerk XI, 9, 1958, pp. 10—12.

Pure plastic art. Masters of abstract art, New York, Helena Rubinstein 1942. Reprinted in Plastic art and pure plastic art, New York 1945, and in Catalogue of Mondrian Exhibition, London, Whitechapel Art Gallery 1955, pp. 46—48.

Pure beelding. Piet Mondriaan herdenkingstentoonstelling, Amsterdam, Stedelijk Museum 1946, pp. 40—43.

Plastique pure. M. Seuphor, L'art abstrait, Paris 1949, pp. 173—176.

Pura arte plastica. Morisani, pp. 176—179.

Abstract art. Art of this century, New York, Peggy Guggenheim 1942. Reprinted in Plastic art and pure plastic art, New York 1945.

L'arte astratta. Morisani, pp. 153—155.

A new realism. Lecture to American Abstract Artists 1942. Published in Plastic art and pure plastic art, New York 1945. Special edition American Abstract Artists, New York 1946.

Un nuovo realismo. Morisani, pp. 180—188.

Vedute vitali. 1944. Morisani, p. 189.

Plastic art and pure plastic art, 1937, and other essays, 1941—1943. New York, Wittenborn 1945 (1947, 1951), Documents of modern art 2. Containing Plastic art and pure plastic art, Liberation from oppression in art and life, Toward the true vision of reality, Pure plastic art, Abstract art, A new realism.

W. Hess, Dokumente zum Verständnis der modernen Malerei. Hamburg 1956, pp. 100—103. Extracts from Die Neue Gestaltung and from Plastic art and pure plastic art.

Literature on Mondrian

This bibliography does not claim to be complete. As regards all literature appearing after 1944, we have confined ourselves, in general, to publications of special biographical importance.

F. M. Lurasco, Onze moderne meesters, Amsterdam 1907.

C. Kickert, St. Lucas; werkende leden-tentoonstelling. Onze kunst VII, Vol. 13, 1908, p. 240.

C. L. Dake, Drie avonturiers in het Stedelijk Museum. De Telegraaf, 7 January 1909.

G. W. Knap, Spoor-Mondriaan-Sluyters Exhibition. De Kunst I, 5, 1909.

Frederik van Eeden, Gezondheid en verval in kunst naar aanleiding van de tentoonstelling Spoor-Mondriaan-Sluyters. Op de hoogte 1909, pp. 79—85.

H. L. Berckenhoff, Mondriaan-Sluyters-Spoor. Nieuwe Rotterdamsche Courant, 8, 9 and 11 January 1909. Reproduced in De Kunst I, 8, 1909.

F. Lapidoth, Kunst in de hoofdstad III. Nieuwe Courant IX, 30, 30 January 1909.

C. Kickert, Piet Mondriaan, Jan Sluyters and C. Spoor. Onze kunst VIII, 2, 1909, pp. 97—98.

N. H. Wolf, St. Lucas' tentoonstelling. De Kunst I, 63 and 67, 1909.

A. Plasschaert, XIX eeuwsche Hollandsche schilderkunst. Amsterdam 1909, p. 103.

A. Plasschaert, P. Mondriaan (St. Lucas, 1910), karakteriseering. Kritieken II, 2, pp. 1—3.

C. Kickert, St. Lucas-ledententoonstelling. Onze kunst IX, Vol. 17, 1910, p. 227.

N. H. Wolf, Tentoonstelling St. Lucas. De Kunst II, 120, 1910.

M. D. Henkel, St. Lucas-Ausstellung. Kunstchronik, 24, 6, 1910.

F. Vermeulen, Werk van Walchersche schilders te Domburg. Elsevier's geïll. maandschrift 21, Vol. 42, 1911, pp. 318, 319.

N. H. Wolf, De Modernen in het Stedelijk Museum. De Kunst IV, 196, 1911, pp. 50, 51.

A. Saalborn, Piet Mondriaan en anderen. De Kunst IV, 197, 1911, pp. 74—77.

K. L.(ilienfeld), Amsterdam (Moderne Kunst Kring). Der Cicerone III, 1911, pp. 928—929.

N. H. Wolf, Sint-Lucas tentoonstelling 1911. De Kunst III, 170, 1911.

A. Plasschaert, Naamlijst van Hollandsche schilders. Amsterdam 1912.

A. de Haas, Uit Domburg. Onze kunst XI, Vol. 22, 1912, pp. 123, 124.

G. Apollinaire, À travers le Salon des Indépendants. Montjoie I, 3, 1913.

Wilmon-Vervaerdt, Exposition internationale du Cercle de l'Art Moderne. De Kunst VI, 302, 1913, p. 86.

A. Salmon, Le Salon des Indépendants. Montjoie 1914.

L. Faust, Salon des Indépendants. De Kunst VI, 322, 1914, p. 403.

D. B., Moderne Kunst Kring. Onze kunst XIII, Vol. 25, 1914, p. 31.

N. H. Wolf, Petrus Alma, Le Fauconnier, Piet Mondriaan. De Kunst VII, 369, 1915, pp. 250—252.

Rotterdamsche Kunstkring. De Kunst VII, 370, 1915, p. 264.

A. (de Meester-)O(breen), Piet Mondriaan. Elsevier's geïll. maandschrift 25, Vol. 50, 1915, pp. 396—399.

N. H. Wolf, Modernen. De Kunst VIII, 403, 1915, p. 30.

Theo van Doesburg, Moderne kunst. De Eenheid, 1915.

J. B., Het kunstenaars-congres. Holland IV, 1, 1915, p. 27.

H. P. Bremmer, Mondriaan, lijnencompositie. Beeldende kunst III, 72, 1915/16, pp. 106—107.

Amsterdam, Stedelijk Museum, Moderne kunst. Onze kunst XV, Vol. 29, 1916, p. 30.

C. V(eth), Hollandsche Kunstenaarskring. Elsevier's geïll. maandschrift 26, Vol. 51, 1916, p. 328.

N. H. Wolf, Hollandsche Kunstenaarskring II. De Kunst VIII, 428, 1916, p. 317.

Theo van Doesburg, De nieuwe beweging in de schilderkunst. Delft 1917.

A. (de Meester-)O(breen), Johan Tielens. Elsevier's geïll. maandschrift 27, Vol. 53, 1917, p. 322.

N. H. Wolf, Tentoonstelling De Bloemen. De Kunst IX, 499, 1917, p. 542.

H. P. Bremmer, Lijncompositie. Beeldende kunst V, 32, 1917/18, pp. 47—48.

V. Huszár, Aesthetische Beschouwingen II. De Stijl I, 3, 1918, pp. 33—35.

Theo van Doesburg, Aanteekeningen bij twee teekeningen van Piet Mondriaan. De Stijl I, 9, 1918, pp. 108—111. Reprinted in Hollandsche Revue 23, 1918, pp. 483—485.

H. C. Verkruysen, De nieuwe schilderkunst. Wendingen I, 1, 1918, pp. 10—17.

H. F. E. Visser, Neuere holländische Malerei. Das Kunstblatt II, 1918, pp. 314—323.

Theo van Doesburg, L'arte nuova in Olanda. Valori plastici 4/5, 1919.

Theo van Doesburg, Drie voordrachten over de nieuwe beeldende kunst. Amsterdam 1919.

A. Plasschaert, Het zien van schilderijen. Arnhem 1919, p. 38.

H. V., V. Huszár bij d'Audretsch, Den Haag, Elsevier's geïll. maandschrift 29, Vol. 58, 1919, p. 67.

A. Petronio, Over het universalisme. De Kunst XII, 610, 1919, p. 9.

G. Kn(uttel), "La Section d'Or" in den Haagschen Kunstkring. Elsevier's geïll. maandschrift 30, Vol. 60, 1920, pp. 283—284.

A. Plasschaert, Hollandsche Kunstenaarskring. Groene Amsterdammer 20. 3. 1920.

Theo van Doesburg, Klassiek — barok — modern. Antwerp 1920.

F. M. Huebner, Die holländische "Stijl"Gruppe. Feuer 1920, pp. 267—278. Quoted in De Stijl IV, 1921, pp. 58—63.

P. Alma, De schilderkunst in Frankrijk en hier. De Nieuwe Amsterdammer, 6 March 1920. Discussed and quoted in:
Theo van Doesburg, Het Picasso'sche kubisme en de Stijlbeweging. De Stijl III, 1920, 11, pp. 89—90 and 12, pp. 99—102.

F. M. Huebner, Die Sammlung Tak van Poortvliet im Haag. Der Ararat 10, 1921, pp. 262—263. Also in:
F. M. Huebner, Moderne Kunst in den holländischen Privatsammlungen. Leipzig/Amsterdam 1921.

F. M. Huebner, Die neue Malerei in Holland. Leipzig/Arnhem 1921, pp. 107—109.

K. Niehaus, L'art hollandais contemporain. Sélection 2, 1922, pp. 169—198.

C. Veth, Piet Mondriaan in den Hollandschen Kunstkring. Elsevier's geïll. maandschrift 32, Vol. 63, 1922, pp. 287—288.

A. Plasschaert, Hollandsche Kunstenaarskring II. Groene Amsterdammer 29. 4. 1922.

N. H. Wolf, Tentoonstelling 1922 van den Hollandschen Kunstenaarskring. De Kunst XIV, 739, 1922, p. 39.

Bij Piet Mondriaan. Nieuwe Rotterdamsche Courant 23. 3. 1922.

A. Plasschaert, De Hollandsche schilderkunst vanaf de Haagsche school tot op den tegenwoordigen tijd. Amsterdam 1923, p. 216.

N. H. Wolf, Bloemen en stillevens. De Kunst XVI, 825, 1923, p. 74.

H. Hana, Piet Mondriaan, de pionier. Wil en weg 2, 1923/24, pp. 602—608 and 635—639. Reprinted in De Fakkel 1, 1925, pp. 62—68 and 74—79.

A. Kemeny, Die abstrakte Gestaltung vom Suprematismus bis heute. Das Kunstblatt 8, 1924, pp. 245—248. Mondrian. Merz II, 8/9, 1924, p. 77.

H. Hildebrandt, Die Kunst des XIX. und XX. Jahrhunderts. Potsdam 1924.

Het neo-plasticisme in schilderkunst, bouwkunst, muziek, literatuur. Het Vaderland 17. 10. 1924.

Theo van Doesburg, Grundbegriffe der neuen gestaltenden Kunst. Munich 1925, p. 33, Illust. 27 (Bauhausbuch 6).

H. Kröller-Müller, Beschouwingen over problemen in de ontwikkeling der moderne schilderkunst. Maastricht 1925, pp. 226—231. Reprinted Leipzig 1925.

A. Behne, Von Kunst zur Gestaltung. Berlin 1925, pp. 79—81.

El Lissitzky and Hans Arp, Die Kunst-ismen. Zurich 1925.

W. Grohmann, P. Mondrian, Man Ray. Der Cicerone XVII, 1925, pp. 1007—1008.

N. H. Wolf, De Onafhankelijken. De Kunst XVII, 906, 1925, p. 427.

N. H. Wolf, Frits Mondriaan. De Kunst XVII, 908, 1925, p. 447.

P. K(oomen), Rotterdam (tentoonstelling Rotterdamsche Kring). Maandblad voor beeldende kunsten 2, 1925, p. 154.

J. D., Vilmos Huszár bij d'Audretsch in Den Haag. Elsevier's geïll. maandschrift 35, Vol. 69, 1925, p. 80.

J. Havelaar, Werk van modernen (in De Bron). Het Vaderland 25. 12. 1925.

Kunst van heden. Nieuwe Rotterdamsche Courant 7. 12. 1925.

Absolute schilderkunst. De Nieuwe Courant 3. 2. 1926.

K. S. Dreier, Modern art. New York 1926.

N. H. Wolf, De Onafhankelijken. De Kunst XVIII, 960, 1926, p. 447.

H., Tentoonstellingen en veilingen, Amsterdam (De Onafhankelijken), Maandblad voor beeldende kunsten 3, 1926, p. 221.

Theo van Doesburg, The progress of the modern movement in Holland. Ray (London) II, 1927, pp. 11—13.

H. van Loon, Piet Mondriaan, de mensch, de kunstenaar. Maandblad voor beeldende kunsten 4, 1927, pp. 195—199.

Theo van Doesburg, Über das Verhältnis von malerischer und architektonischer Gestaltung (mit einer Einführung zur Stijlbewegung). Der Cicerone XIX, 1927, pp. 564—570.

N. H. Wolf, De Onafhankelijken. De Kunst XIX, 1011, 1927, p. 454.

Documents internationaux de l'Esprit Nouveau 1, 1927.

G. F. Hartlaub, Rückblick auf den Konstruktivismus. Das Kunstblatt XI, 1927, p. 261.

E. Kállai, Antwort. Internationale revue i 10, I, 6, 1927, pp. 237—240.

P. Alma, Kunst en samenleving. Internationale revue i 10, I, 7, 1927, pp. 242, 244.

A. Plasschaert, Overzicht: de nu werkende schilders in Holland. Maandblad voor beeldende kunsten 4, 1927, pp. 40—41.

Pulchri Studio: hedendaagsche Parijsche schilderkunst. Nieuwe Rotterdamsche Courant 18. 12. 1929.

A. Sartoris, Elementarismo. Belvedere, May-June 1930.

P. Citroen, Palet. Amsterdam 1931, pp. 76—82.

Sven Bocklund, Piet Mondrian. Hyresgasten (Göteborg) 20, 1931, pp. 1—3.

A. Doerner, Considérations sur la signification de l'art abstrait. Cahiers d'art 6, 1931, pp. 354—357.

J. Bendien, Piet Mondriaan 60 jaar. Elsevier's geïll. maandschrift 42, Vol. 84, 1932, pp. 168—174.

P. Fierens, L'art hollandais contemporain. Paris 1933, pp. 17—19.

W. Grohmann, Die Sammlung Ida Bienert. Potsdam 1933.

A. M. Hammacher, In memoriam Jacob Bendien. Forum III, 2, 1934.

G. Knuttel, La peinture en Hollande. Histoire de l'art contemporain, L'amour de l'art, 1934, p. 404.

J. J. Sweeney, Plastic redirections in 20th century painting. Chicago 1934.

Theo van Doesburg, Neoplasticisme. D'aci i d'alla (Barcelona) 1934.

Jos. de Gruyter, Wezen en ontwikkeling der Europeesche schilderkunst na 1850. Amsterdam 1935, pp. 201—202. 2nd ed., 1954, pp. 264, 266—268.

J. Bendien, Richtingen in de hedendaagsche schilderkunst. Rotterdam 1935.

J. Torres García, Estructura. Montevideo 1935.

G. Grigson, The arts to-day. London 1935.

A. H. Barr, Cubism and abstract art. New York 1936, pp. 140—152, 217.

A. Sartoris, El pintor elementarista Piet Mondrian. Fábula 1937.

A. Sartoris, Mondrian. Origini (Rome), October 1937.

A. Sartoris, Piet Mondrian. Campografico (Milan), 1938.

C. Giedion-Welcker, Modern plastic art. Zurich 1937.

Ch. Zervos, Histoire de l'art contemporain. Paris, Cahiers d'art 1938.

H. Modsen, Från symbolism til surrealism. Stockholm 1939.

H. Buys, Piet Mondriaan; de werkelijke waarde der tegenstellingen. Kroniek van hedendaagsche kunst en kultuur V, 3, 1939, pp. 34—36.

H. Luns, Holland schildert. Amsterdam (1940), p. 419.

Sidney Janis, School of Paris comes to U.S.A. Decision II, 5/6, 1941, pp. 89—91.

H. van Loon, Piet Mondriaan 70 jaar. Nieuwe Rotterdamsche Courant 6. 3. 1942.

R. Frost, Contemporary art. New York 1942, pp. 23, 226—227.

K. Niehaus, Levende Nederlandsche kunst. Amsterdam 1942, pp. 166, 167, 189.

R. Motherwell, Notes on Mondrian and Chirico. VVV 1942, pp. 58—62.

H. Felix Kraus, Mondrian, a great modern Dutch painter. Knickerbocker weekly II, 30, 1942, pp. 24—25.

Max Bill, Aan Piet Mondriaan op zijn 70e verjaardag. De 8 en Opbouw XII, 12, 1942.

S. M. Kootz, New frontiers in American painting. New York 1943, pp. 50—53.

George L. K. Morris, Relations of Painting and Sculpture. Partisan Review X, 1, 1943, pp. 63—71.

C. von Wiegand, The meaning of Mondrian. Journal of aesthetics and art criticism II, 8, 1943, pp. 62—70.

Jay Bradley, Pieter Mondrian 1872–1944; as Ernst remembers Mondrian. Knickerbocker Weekly III, 1944, pp. 16–25.

Robert Motherwell, Painters' objects. Partisan Review XI, 1, 1944, pp. 93–97.

Maude Riley, Mondrian dies. Art digest 18, 1944, p. 23.

J. J. Sweeney, Piet Mondrian. Partisan Review XI, 2, 1944, pp. 173–176

Interview with Harry Holtzman. Studio/New Yorker 20, 1944, pp. 20–22.

J. J. Sweeney, Piet Mondrian. Museum of Modern Art bulletin XII, 4, 1945. Reprinted 1948 and followed by an Interview with Mondrian.

Serge Chermayeff, Mondrian of the Perfectionists. Art News 44, 1945, p. 22.

Harriet Janis, Notes on Piet Mondrian. Arts and architecture 62, 1945, pp. 28–30.

Mondrian makes the mode. Art News 44, 1945, p. 22.

C. Sterling, Art français en Amérique. Amour de l'art 25, 1945, p. 35.

H. A. van Anrooy, Piet Mondriaan. Forum I, 1946, p. 264.

J. J. Sweeney, An interview with Mondrian. Museum of Modern Art bulletin XIII, 4/5, 1946.

Eleven Europeans in America. Museum of Modern Art bulletin XIII, 4/5, 1946.

Park Tyler, Mondrian and the squaring of the circle. Arts and architecture 63, 1946, pp. 32, 50.

Piet Mondriaan Commemorative Exhibition. Amsterdam, Stedelijk Museum 1946. Catalogue with contributions by M. Seuphor, Til Brugman, P. Alma, J. J. P. Oud and C. van Eesteren.

Piet Mondrian. Cahiers d'art 22, 1947, pp. 103–104.

Harry Holtzman, P. M., The League Quarterly XIX, 1, 1947.

A. M. Hammacher, Piet Mondriaan. Kroniek van kunst en kultuur VIII, 9, 1947, pp. 233–237.

J. Alford, Last lines of Mondrian. College art journal VIII, 1, 1948, pp. 14–16.

M. Seuphor, Piet Mondrian et les origines du Néo-plasticisme. Art d'aujourd'hui 5, 1949, pp. 3–4.

J. A. Gorin, Influence de Mondrian. Art d'aujourd'hui 5, 1949, p. 8.

Oscar Reutersvard, Carlsund och neoplasticismen. Konsthistorisk Tidskrift 18, 1949, pp. 19–27.

The only artist who influences storage unit design is Mondrian. Interiors, N. Y., 108, 1949, July.

M. Seuphor, Suprématisme et Néo-plasticisme. Art d'aujourd'hui 7/8, 1950, pp. 22–24.

D. C. Bayón, Piet Mondrian. Ver y estimar (Buenos Aires) V, 17, 1950, pp. 21–30.

Pierre Guégen, Platon et l'art abstrait. XXe siècle, Nouvelle série, 1951, I, p. 19.

A. W. Levi, Mondrian as metaphysician. Kenyon Review XIII, 3, 1951, pp. 385–393.

J. J. Sweeney, Mondrian, the Dutch and "De Stijl". Art News 50, 4, 1951, pp. 25–27, 62–64.

F. Vordemberge-Gildewart, Zur Geschichte der "Stijl"-Bewegung. Werk 38, 1951, pp. 349–356.

Max Bill, De la Surface à l'Espace. XXe siècle, Nouvelle série, 1952, 2, pp. 59–65.

M. Seuphor, Histoire sommaire du tableau-poème. XXe siècle n. s. 2, 1952, pp. 21–26.

M. Seuphor, Piet Mondrian 1914–18. Magazine of art 45, 5, 1952, pp. 216–223.

De Stijl 1917–1928. Museum of Modern Art bulletin XX, 2, 1952/53.

S. Tillim, Space, time and Mondrian; 50 years of work on view at the Sidney Janis Gallery. Art Digest 28, 1953, 15 Nov., p. 18.

B. Zevi, Poetica dell'architettura neoplastica. Milan 1953.

M. Seuphor, Mondrian indésirable. Art d'aujourd'hui V, 1, 1954, p. 1.

M. Seuphor, Neglect of Mondrian. Art Digest 29, 1954, 15 Feb., p. 16.

M. Seuphor, Mondrian peintre figuratif. XXe siècle n. s. 4, 1954, pp. 25—27.

W. Klein, Mondrian in natura. Domus 290, 1954, pp. 44—46.

M. Seuphor, Mondriaan. Gemeentemuseum Catalogue, The Hague 1955.

J. J. P. Oud, Mondriaan. De Groene Amsterdammer 12. 2. 1955.

G. T. Rietveld, Mondriaan en het nieuwe bouwen. Bouwkundig weekblad 73, 1955, pp. 127—128.

Louis Saalborn, Herinneringen aan Mondriaan. De Telegraaf 17. 3. 1955.

D. Lewis, Mondrian in London. Museumjournaal I, 1955, pp. 81—85.

M. Seuphor, Humanisme de Mondrian. Aujourd'hui 2, 1955, pp. 5—9.

M. Seuphor, Piet Mondrian; life and work; 1st ed., New York/Amsterdam 1956; German ed., Cologne 1956.

M. Seuphor, De Stijl. L'Oeil, October 1956.

W. Sandberg, Mondrian; l'organisation de l'espace. Quadrum 2, 1956. The Mondrian Room at the Biennale in Venice; also included in Catalogue of the Mondrian Exhibition at the Denise René Gallery, Paris 1957.

O. Morisani, L'astrattismo di Piet Mondrian; con appendice di scritti dell'artista. Venice 1956.

H. L. C. Jaffé, De Stijl. Amsterdam 1956.

Martin S. James, The Realism behind Mondrian's Geometry, Art News LVI, Dec. 1957, pp. 34—37.

A. Jouffroy, Mondrian vu par Hélion. Arts 611, 20. 3. 1957, p. 13.

M. Seuphor, L'oeuvre figurative de Mondrian. Apollo 65, 1957, pp. 261—263.

M. Seuphor, Piet Mondrian et le nouveau réalisme. XXe siècle 9, 1957, pp. 8—10.

M. Seuphor, Le retour de Mondrian. Aujourd'hui 11, 1957, pp. 4—11.

D. Gioseffi, La falsa preistoria di Piet Mondrian e le origini del Neoplasticismo. Trieste 1957.

Mondrian; présenté par Vasarely: introduction par Michel Seuphor. Paris 1957. Album of pictures published by the Denise René Gallery.

D. Lewis, Mondrian. London 1957; German ed., Berlin 1960.

S. Hunter, Mondrian. London 1958.

M. Seuphor, Mondriaan, composities. The Hague 1958. Kleine kunst-encyclopaedie 15.

J. Baljeu, Mondrian or Miro? Amsterdam 1958.

D. Suro, L'espace, Mondrian et Picasso. Aujourd'hui 20, 1958, pp. 28—29.

L. Zahn, Piet Mondrian. Das Kunstwerk XI, 9, 1958, pp. 3—4.

A. B. Terpstra, Moderne kunst in Nederland 1900—1914. Utrecht 1958/59.

H. L. C. Jaffé, Inleiding tot de kunst van Mondriaan. Assen/Amsterdam 1959.

C. Wentinck, De Nederlandse schilderkunst sinds Van Gogh. Nijmegen 1959, p. 160.

M. van Domselaer-Middelkoop, Herinneringen aan Piet Mondriaan, Maatstaf 7, 1959/60, pp. 269—293.

H. L. C. Jaffé, Il gruppo "De Stijl". Amsterdam 1960.

Alfred H. Barr, De Stijl Cat., 1917—1928. New York, Museum of Modern Art, 1961.

M. Seuphor, Mondrian l'inactuel. Quadrum 12, 1961, pp. 4—20.

C. Blok, Mondriaan's vroege werk. Museumjournaal VIII, 2, 1962, pp. 34—38.

L. J. F. Wijsenbeek and J. J. P. Oud, Mondriaan. Zeist 1962.

C. L. Ragghianti, Mondrian e l'arte del XX secolo. Milan 1962.

F. Menna, Mondrian; cultura e poesia. Rome 1962.

H. L. C. Jaffé, De Stijl, Amsterdam 1963.

Martin S. James, Mondrian and the Dutch Symbolists, The Art Journal XXIII, No. 2, winter 1963–64, pp. 103–111.

C. Blok, Eindpunt en begin. Naar aanleiding van de Didactische Tentoonstelling te Den Haag, Gemeentemuseum, 1964.

Robert P. Welsh, Mondrian and the period of the evening landscapes. Piet Mondrian Cat., Allan Frumkin Gallery, New York 1964.

A. M. Hammacher, The Stijl and their impact. Cat. of Marlborough-Gerson Gallery, New York 1964.

Kim Levin, Kiesler and Mondrian, An Art into Life. Art News LXIII, 1964/65, pp. 38–41.

Georg Schmidt, Mondrian today. Piet Mondrian Cat., Galerie Beyeler, Basle, 1964/65.

Michel Seuphor, Le Style et le cri. Quatorze essais sur l'art de ce siècle, Paris, 1965.

Joost Baljeu, The Problem of Reality with Suprematism, Constructivism, Proun, Neoplasticism and Elementarism. The Lugano Review I, No. 1, 1965, pp. 105–124.

R. Oxenaar, Piet Mondrian, Composition in red, yellow and blue, 1939–42. In: Dutch Painting, Twelve studies in Dutch painting from the 17th to the 20th century, related to the BBC radio series Painting of the Month, London, BBC, 1965, pp. 84–88.

C. Blok, Documentatie. Nieuws over Mondriaan. Museumjournaal 11, No. 5, 1966, pp. 134–135.

Robert P. Welsh, The Hortus Conclusus of Piet Mondrian. The Connoisseur 161, No. 648, Feb. 1966, pp. 132–135.

Robert P. Welsh, Landscape into Music: Mondrian's New York Period. Arts Magazine 40, Feb. 1966, pp. 33–39.

Robert P. Welsh, The growing influence of Piet Mondrian. Canadian Art 13, Jan. 1966, pp. 44–49.

Robert P. Welsh, Piet Mondrian 1872–1944. Cat., Toronto/Philadelphia 1966.

K. Herberts, Offenbarungen in der Malerei des 20. Jahrhunderts. Vienna [1966].

Robert Rosenblum, Mondrian and Romanticism. Art News 64, Feb. 1966, No. 10, pp. 33–37, 69–70.

Brydon Smith, The search for an universal plastic expression. Canadian Art 13, Oct. 1966, pp. 14–17.

Michel Seuphor, Mondrian et la pensée de Schoenmaekers. Werk 53, No. 9, Sept. 1966, p. 362 ff.

Fernande Saint-Martin, Mondrian ou un Nouvel Espace Pictural. Vie des Arts 1966, pp. 70–72.

R. P. Lohse, "Standard, Series, Module: New Problems and Tasks of Painting", in: Module, Proportion, Symmetry, Rhythm, edited by G. Kepes, New York, G. Braziller, Vision + Value Series, 1966, p. 128.

G. Rickey, Constructivism; origins and evolution. New York 1967.

D. Vallier, L'art abstrait. Paris 1967.

H. L. C. Jaffé, Mondrian und De Stijl, Cologne 1967.

Robert P. Welsh and J. M. Joosten, Mondrian's Sketchbooks, Amsterdam 1968.

H. L. C. Jaffé, Mondrian, New York 1968.

Theodore M. Brown, Mondrian and Rietveld. Nederlands Kunsthistorisch Jaarboek 19, Bussum 1968, p. 205 ff.

H. L. C. Jaffé, "Een gedateerde plafondschildering door Piet Mondriaan", in: Oud Holland, driemaandelijks tijdschrift voor Nederlandse kunstgeschiedenis, LXXXIII, 1968, No. 3/4, p. 229.

R. P. Lohse, "Elementarism. Series. Modulus", in: Data, Directions in Art, Theory and Aesthetics, an anthology edited by A. Hill, London, Faber and Faber, 1968, p. 58.

Bibliographical data on Piet Mondrian from Index of Museumjournaal, series 13, 1968.

J. M. Joosten, Mondriaan — 26 brieven van Piet Mondriaan aan Lod. Schelfhout and H. P. Bremmer 1910–1918. Documentation about 10 letters 1910–1914 (No. 1, p. 208), 6 letters 1915 — March 1916 (No. 2, p. 267), 10 letters 1916–1918 (No. 3, p. 321).

Index

List of works illustrated

GM = owned by the Haags Gemeentemuseum, The Hague

GM/SBS = S. B. Slijper Collection, Blaricum, on loan to the Haags Gemeentemuseum, The Hague

1 Haystacks 1891
oil on cardboard 28.5 x 38 cm
signed bottom right: P. Mondriaan
S. B. Slijper Collection, Blaricum

2 Drydock at Durgerdam 1898
watercolor on paper 45 x 61 cm
signed bottom right: P. Mondriaan
Collection of Madame Cuvelier, Brussels

3 Photograph of a drydock at Durgerdam

4 Dredge 1907
oil on cardboard upon wood 63.4 x 75.5 cm
signed bottom left: P. Mondriaan '07
Collection of Mr. and Mrs. James H. Clark,
Dallas

5 Church at Winterswijk 1898
etching 35.5 x 25.3 cm
not signed
Collection of Mr. and Mrs. Karl H. Gans,
New York

6 Church at Winterswijk 1898
oil on paper
Private collection, Amsterdam

7 Farm near Blaricum 1898/1900
oil on cardboard 45.5 x 56 cm
signed bottom right: P. Mondriaan
GM/SBS

8 Factory 1899
crayon on paper 19 x 27 cm
signed bottom right: P. Mondriaan
J. P. Smid Collection, Amsterdam

9 Contemporary photo of the same factory

10 Sketch of cows 1904
oil on canvas 31.5 x 41.5 cm
signed bottom left: P. Mondriaan
GM/SBS

11 In het Gein: trees with rising moon
1907/08
oil on paper 63 x 75 cm
signed bottom left: P. Mondriaan
GM/SBS

12 Winter landscape 1907/08
oil on canvas 35.5 x 61.5 cm
signed bottom right: Piet Monriaan (sic)
Collection of Dr. P. Dobbelman, Nijmegen
Photograph: Bert Buurman, Amsterdam

13 Trees on the Gein 1905/06
oil on canvas 45 x 66 cm
not signed
GM/SBS

14 The Amstel, "evening mood" 1906/07
charcoal on paper 34 x 49.3 cm
not signed
GM/SBS

15 Farm at Nistelrode 1904
watercolor on paper 44.5 x 63 cm
not signed
GM

16 Windmill near Blaricum in the moonlight 1906/07
oil on canvas 99.5 x 125.5 cm
signed bottom right: P. Mondriaan
GM

17 Summer night, landscape with full moon 1907
oil on canvas 71 x 110.5 cm
not signed
GM

18 Farm near Duivendrecht 1905
charcoal on paper 46.3 x 60 cm
not signed
The Art Gallery, Toronto

19 Farm near Duivendrecht about 1906/07
oil on canvas 85.5 x 108.5 cm
signed bottom right: P. Mondriaan
GM/SBS

20 Trees on the Gein 1905/06
charcoal on paper 19 x 27 cm
not signed
Museum of Fine Arts, Boston

21 Solitary tree 1903/06
oil on canvas 65 x 86 cm
not signed
GM

22 Trees on the Gein 1908
oil on canvas 69 x 112 cm
signed bottom right: P. Mondriaan
Collection of Hannema —
de Stuers Stichting, Heino

23 The red cloud 1907/09
oil on cardboard 64 x 75 cm
signed bottom right: P. Mondriaan
GM

24 Windmill on the Gein 1907/08
oil on canvas 99.6 x 125.7 cm
signed bottom right: P. Mondriaan
Allan Frumkin Gallery, New York

25 Evening landscape 1907/08
oil on canvas 64 x 93 cm
not signed
GM

26 Chrysanthemum 1901
watercolor on paper 38.3 x 19.3 cm
signed bottom left: Piet Mondriaan
Collection of H. M. the Queen of the Netherlands

27 Dying chrysanthemum 1908
oil on canvas 84.5 x 54 cm
signed bottom left: Piet Mondriaan
GM/SBS

28 Study for a windmill 1908
present whereabouts unknown

29 Windmill at Domburg 1909
oil on cardboard 76.5 x 63.5 cm
signed bottom right: Piet Mondriaan
GM

30 Haystacks 1909
oil on canvas 30 x 43 cm
not signed
Courtesy Sidney Janis Gallery, New York

31 Woods near Oele 1908
oil on canvas 128 x 158 cm
signed bottom right: Piet Mondriaan
GM/SBS

32 "Spring" 1908
black crayon on cardboard 69.5 x 46 cm
signed bottom left: P. M.,
bottom right: Printemps
GM/SBS

33 Portrait of a woman 1908?
watercolor on paper 89 x 50 cm
signed bottom left: Piet Mondriaan
GM/SBS

34 Praying child 1908
oil on canvas 94 x 61 cm
signed bottom left: Piet Mondriaan
GM/SBS

35 Chrysanthemum before 1911?
watercolor on paper 28.5 x 24.5 cm
signed bottom left: P. Mondriaan
GM/SBS

36 Chrysanthemum about 1909
charcoal on paper 78.5 x 46.2 cm
signed bottom left: P. Mondriaan
GM/SBS

37 "Evolution," triptych 1910/11
oil on canvas, middle panel 183 x 87.5 cm
side panels 178 x 85 cm
all signed bottom right: P. M. (monogram)
GM/SBS

38 Lily 1909
watercolor on paper 39 x 44 cm
signed bottom right: P. M. (monogram)
Collection of Mevrouw A. C. H. W. Smid-Verlee,
Amsterdam

39 Amaryllis 1910
watercolor on paper 72.5 x 47 cm
signed bottom right: P. M. (monogram)
Sheldon Memorial Art Gallery,
The University of Nebraska

40 Amaryllis 1910
watercolor on paper 39 x 49 cm
signed bottom right: P. M. (monogram)
Collection of Mevrouw A. C. H. W. Smid-Verlee,
Amsterdam

41 Windmill in the sunlight 1908
oil on canvas 114 x 87 cm
signed bottom right: Piet Mondriaan
GM/SBS

42 Windmill in the moonlight I about 1908/09
charcoal on paper 105 x 90 cm
not signed
GM/SBS

43 Windmill in the moonlight II about 1909/10
charcoal on paper 103 x 83.5 cm
signed bottom left: P. Mondriaan
GM/SBS

44 Windmill near Blaricum in the moonlight
about 1916
oil on canvas 103 x 86 cm
signed bottom left: Piet Mondriaan
GM/SBS

45 Windmill in the sunlight 1908
see Illustration 41

46 Windmill at Domburg (The red mill) 1910/11
oil on canvas 150 x 86 cm
signed bottom left: P. M. (monogram)
GM/SBS

47 Windmill at Domburg 1909
oil on cardboard 76.5 x 63.5 cm
signed bottom right: Piet Mondriaan
GM/SBS

48 Church tower at Domburg 1910/11
oil on canvas 114 x 75 cm
signed bottom left: P. M. (monogram)
GM/SBS

49 Church at Domburg 1909
India ink on paper 41.5 x 28 cm
signed bottom right: P. M. (monogram)
GM/SBS

50 Church tower at Domburg 1909
oil on cardboard 36 x 36 cm
signed bottom left: P. Mondriaan
GM/SBS

51 Church tower at Domburg 1909/10
oil on canvas 76 x 65.5 cm
signed bottom right: Piet Mondriaan
GM/SBS

52 Church tower at Zoutelande 1910
oil on canvas 90.7 x 62.2 cm
signed bottom left: P. M. (monogram) 1910
Collection of Mrs. Phyllis Lambert, Chicago
Photograph: Richard Feigen Gallery Inc., Chicago

53 The red tree 1908
oil on canvas 70 x 99 cm
signed bottom left: P. M. (monogram)
GM

54 Tree I about 1909/10
black crayon on paper 31 x 44 cm
signed bottom right: P. Mondriaan
GM

55 Tree II 1912
black crayon on paper 56.5 x 84.5 cm
signed bottom left: P. Mondrian
GM

56 The gray tree 1912
oil on canvas 78.5 x 107.5 cm
signed bottom left: P. Mondrian
GM/SBS

57 The blue tree about 1909/10
tempera on cardboard 75.5 x 99.5 cm
signed bottom right: Piet Mondriaan
GM

58 Sketch for trees II 1913
charcoal on paper 65.5 x 87.5 cm
signed bottom left: P. Mondriaan
GM

59 Flowering appletree 1912
oil on canvas 78 x 106 cm
not signed
GM

60 Trees 1912
black crayon on paper 73 x 63 cm
signed bottom right: P. Mondriaan
GM

61 Tree 1912
black crayon on paper 65 x 89 cm
signed bottom right: P. Mondriaan
GM

62 Tree 1912
oil on canvas 94 x 69.8 cm
not signed
Patrons Art Fund, Museum of Art, Carnegie
Institute, Pittsburgh, Pa.

63 Dune V 1909/10
oil on canvas 65.5 x 96 cm
signed bottom right: P. M. (monogram)
GM

64 Dunes at Domburg 1911
charcoal on paper 44.6 x 67.8 cm
signed bottom left: P. M. (monogram)
Collection of Dr. L. U. de Sitter, Leiden

65 Dunes and sea 1909
crayon on paper 10.5 x 17.2 cm
signed bottom left: Piet Mondrian 1909
Collection of Miss Charmion von Wiegand,
New York

66 Dunes and sea 1909
crayon on paper 10.5 x 17.2 cm
not signed
Marlborough Fine Art Ltd., London

67 Sea at sunset 1909
oil on cardboard 62.5 x 74.5 cm
signed bottom left: Piet Mondriaan
GM

68 The sea (Zeeland) 1909
oil on cardboard 34.5 x 50.5 cm
signed bottom right: P. Mondriaan
GM/SBS

69 Dune II 1909
oil on canvas 37.5 x 46.5 cm
signed bottom right: P. M. (monogram)
GM/SBS

70 Dune III 1909
oil on cardboard 29.5 x 39 cm
signed bottom left: P. Mondriaan
GM/SBS

71 Dunes 1910/11
oil on canvas 141 x 239 cm
signed bottom left: P. M. (monogram)
GM/SBS

72 Landscape 1911
oil on canvas 63 x 78 cm
signed bottom right: P. Mondrian
GM/SBS

73 Still life with ginger jar I 1911
oil on canvas 65.5 x 75 cm
signed bottom right: P. Mondrian
GM/SBS

74 Still life with ginger jar II 1911/12
oil on canvas 91.5 x 120 cm
signed bottom right: Mondrian
GM/SBS

75 Landscape with trees 1911
oil on canvas 120 x 100 cm
signed bottom right: P. Mondrian
GM/SBS

76 Figure 1911
oil on canvas 115 x 88 cm
signed bottom right: Mondrian
GM/SBS

77 Nude 1911
oil on canvas 140 x 98 cm
signed bottom right: Mondrian
GM/SBS

78 Composition 2 with lines and colors 1913
oil on canvas 88 x 115 cm
signed bottom right: Mondrian 1913
Rijksmuseum Kröller-Müller, Otterlo

79 Oval composition 1913/14
oil on canvas 107.6 x 78.8 cm
signed bottom left of oval: Mondrian
The Museum of Modern Art, New York.
Purchase

80 Composition 8 1914
oil on canvas 94.5 x 55.5 cm
signed bottom left: Mondrian 1914
The Solomon R. Guggenheim Museum, New York

81 Composition 6 1914
oil on canvas 88 x 61 cm
signed bottom left: Mondrian 1914
GM/SBS

82 Composition 9 ("Blue façade") 1913/14
oil on canvas 95.2 x 67.5 cm
signed bottom right: Mondrian
The Museum of Modern Art, New York.
Gift of Mr. and Mrs. Armand P. Bartos

83 Oval Composition: "KUB" 1913/14
oil on canvas 113 x 84.5 cm
signed bottom left of oval: Mondrian
GM/SBS

84 Composition 1916
oil on canvas 120 x 74.9 cm
signed bottom left: P. Mondriaan '16
The Solomon R. Guggenheim Museum, New York

85 Composition 10 (Pier and ocean) 1915
oil on canvas 85 x 108 cm
signed bottom left: P. Mondriaan '15
Rijksmuseum Kröller-Müller, Otterlo

86 Composition in black and white (plus-and-minus)
1917
oil on canvas 108 x 108 cm
signed bottom left: P. M. (monogram) '17
Rijksmuseum Kröller-Müller, Otterlo

87 Composition 3 with color planes 1917
oil on canvas 48 x 61 cm
signed bottom left: P. M 17
GM

88 Diamond with gray lines 1918
oil on canvas 121 cm diagonal
signed bottom: P. 18 M
GM

89 Composition: Color planes with gray outlines
1918
oil on canvas 49 x 60.5 cm
signed bottom left: P. M. 18
Collection of Professor Max Bill, Zurich

90 Composition: "Checkerboard," dark colors 1918
oil on canvas 84 x 102 cm
signed bottom left: P. M. '19
GM/SBS

91 Composition: "Checkerboard," bright colors 1919
oil on canvas 86 x 106 cm
signed bottom left: P. M '19
GM/SBS

92 Diamond with gray lines 1919
oil on canvas 60 cm diagonal
signed bottom center: PM '19
Rijksmuseum Kröller-Müller, Otterlo

93 Composition with red, blue, and yellow-green
1920
oil on canvas 67 x 57 cm
signed bottom center: PM 20
Collection of Wilhelm Hack, Cologne
Photograph: Rheinisches Bildarchiv, Cologne

94 Composition with red, yellow, blue,
and black 1921
oil on canvas 59.5 x 59.5 cm
signed bottom center: P M '21
GM

95 Tableau II 1921/25
oil on canvas 75 x 65 cm
signed bottom left: PM '21–25
Collection of Professor Max Bill, Zurich

96 Composition 1921
oil on canvas 103.5 x 99.5 cm
signed bottom left: Mondrian
privately owned (Switzerland)

97 Composition I with red, yellow, and blue 1921
oil on canvas 103 x 100 cm
signed bottom right: PM 21
GM/SBS

98 Sketch for Tableau I 1921
charcoal on paper 88.2 x 60.3 cm
not signed
Harry Holtzman Collection, Lyme, Conn.

99 Tableau I 1921
oil on canvas 96.5 x 60.5 cm
signed bottom left of center: PM 21
Wallraf-Richartz-Museum, Cologne

100 Composition with red, yellow, and blue 1921
oil on canvas 80 x 50 cm
signed bottom left: PM 21
GM

101 Composition with white, gray, yellow,
and blue 1922
oil on canvas 54.4 x 52.5 cm
signed bottom left: PM 22
private collection, Switzerland

102 Composition in a square with red, yellow,
and blue 1926
oil on canvas 142.8 cm diagonal
signed bottom center: PM
Collection of Herbert and Nannette Rothschild,
New York

103 Composition 2 1922
oil on canvas 55.5 x 53.5 cm
signed bottom right: PM (monogram) 22
The Solomon R. Guggenheim Museum, New York

104 Composition (diamond) 1925
oil on canvas 109 cm diagonal
not signed
privately owned (Holland)
Photograph: Duiker, Zeist

105 Composition with yellow, red, and blue 1927
oil on canvas 50 x 35 cm
signed bottom right: PM 27
privately owned (Switzerland)

106 Tableau N VII. Composition with blue, yellow,
black, red 1925
oil on canvas 48.5 x 43.5 cm
signed bottom left: PM 25
Kaiser Wilhelm Museum, Krefeld

107 Composition with red, yellow, and blue 1927
oil on canvas 40 x 52 cm
signed bottom left: PM '27
Collection of Jhr. M. J. I. de Jonge van Ellemeet,
Arnhem

108 Composition I with blue and yellow
(diamond) 1925
oil on canvas 112 cm diagonal
signed bottom center: PM 25
Kunsthaus, Zurich
Photograph: Walter Drayer, Zurich

109　Composition　1927
oil on canvas　38.5 x 36 cm
signed bottom right: PM '27
D. and J. de Menil Collection, Houston

110　Composition　1929
oil on canvas　52 x 52 cm
signed bottom right: PM 29
Collection of Marguerite Arp-Hagenbach, Basel

111　Composition with yellow and blue　1929
oil on canvas　52 x 52 cm
signed bottom right: PM 29
Boymans-van Beuningen Museum, Rotterdam

112　Composition II, with black lines　1930
oil on canvas　50 x 51 cm
signed bottom left: PM 30
Stedelijk van Abbemuseum, Eindhoven
Photograph: Martien F. J. Coppens, Eindhoven

113　Composition with yellow lines (diamond)　1933
oil on canvas　113 cm diagonal
signed bottom left: PM 33
GM

114　Composition with blue and yellow　1932
oil on canvas　40.6 x 32.5 cm
signed bottom left: PM 32
Philadelphia Museum of Art,
A. E. Gallatin Collection

115　Fox Trot A　1930
oil on canvas　108 cm diagonal
signed bottom left: PM '30
Collection Société Anonyme, Yale University Art
Gallery, New Haven, Conn.

116　Rhythm with black lines　1935/42
oil on canvas　68.9 x 71.4 cm
signed bottom right: PM 35/42
Kunstsammlung Nordrhein-Westfalen, Dusseldorf

117　Composition with yellow spot　1936
oil on canvas　73 x 66 cm
signed bottom right: PM 36
Philadelphia Museum of Art, The Louise and
Walter Arensberg Collection

118　Composition II with blue　1936/42
oil on canvas　61 x 61 cm
signed bottom right: PM 36
The Museum of Modern Art, New York.
Gift of Sidney Janis

119　Composition with black lines　about 1933
present whereabouts unknown

120　Composition with yellow　1935
oil on canvas　58.3 x 55.2 cm
signed bottom right: PM 35
Collection of Dr. R. E. Blum, Zumikon/Zurich

121　Composition with blue　1937
oil on canvas　80 x 77 cm
signed bottom right: PM 37
GM

122　Composition with red and blue　1936
oil on canvas　98 x 80 cm
signed bottom center: PM 36
Collection of Felix Witzinger, Indianapolis

123　Composition with red, yellow, and blue　1939/42
oil on canvas　72 x 69 cm
signed bottom right: 39/42
The Tate Gallery, London

124　Composition London　1940/42
oil on canvas　82.5 x 71 cm
signed bottom left: PM, bottom right: 40/42
Albright-Knox Art Gallery, Buffalo

125　Composition with blue and yellow　1937
oil on canvas　55.8 x 45 cm
signed bottom right: PM, bottom left: 37
The Museum of Modern Art, New York
Gift of Sidney Janis

126　New York City I　1941/42
oil on canvas　119.3 x 114.2 cm
signed bottom left: PM, bottom right: 42
Courtesy Sidney Janis Gallery, New York

127　Broadway Boogie-Woogie (sketch I)　1942
　　　charcoal on paper　22.8 x 22.8 cm
　　　signed bottom center: PM, bottom right: 42
　　　Collection of Mr. and Mrs. Arnold Newman,
　　　New York

128　Broadway Boogie-Woogie　1942/43
　　　oil on canvas　127 x 127 cm
　　　signed bottom left: PM, bottom right: 42/43
　　　The Museum of Modern Art, New York

129　Victory Boogie-Woogie (sketch)　1943
　　　pencil on paper　48.5 cm diagonal
　　　The Museum of Modern Art, New York
　　　Gift of Sidney Janis

130　Victory Boogie-Woogie　1943/44
　　　oil on canvas　125 cm diagonal
　　　not signed
　　　Collection of Mr. and Mrs. Burton Tremaine,
　　　Meriden, Conn.

Unless otherwise stated, the photographs reproduced here have been provided by the Museum or Collection indicated.